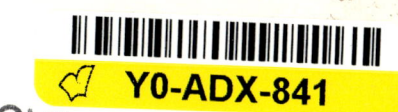

Alfred R. Waud

Civil War Artist

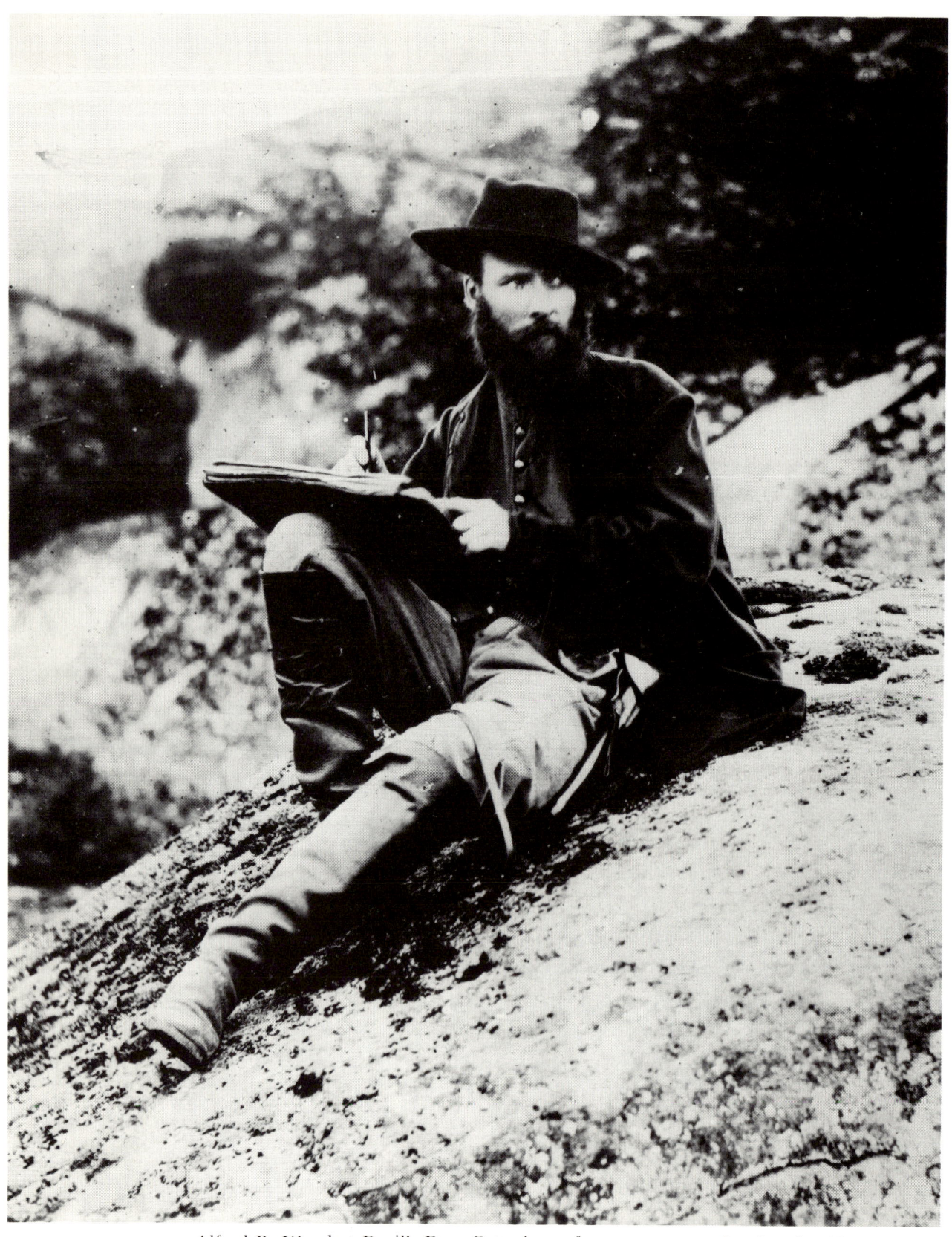

FRONTSPIECE: Alfred R. Waud at Devil's Den, Gettysburg, from a stereograph taken by Alexander Gardner on July 4, 1863. (Collection of the Library of Congress)

ALFRED R. WAUD

Civil War Artist

FREDERIC E. RAY

A Studio Book · The Viking Press · New York

To
the memory of
ALFRED R. WAUD
and that handful of field artists and
photographers whose talents and energies
produced for posterity an unparalleled
pictorial record of the American Civil War

Copyright © 1974 by Frederic E. Ray
All rights reserved
First published in 1974 by The Viking Press, Inc.
625 Madison Avenue, New York, N.Y. 10022
Published simultaneously in Canada by
The Macmillan Company of Canada Limited
SBN 670-11260-7
Library of Congress catalog card number: 73-20667
Printed in U.S.A.

CONTENTS

FOREWORD 7

PART I

AN ARTIST GOES TO WAR 11
THE "SPECIALS" 27
YORKTOWN TO APPOMATTOX 33
AFTERWARD 53
EPILOGUE 71

PART II

THE PLATES 73
LIST OF THE PLATES 184
APPENDIX 186
BIBLIOGRAPHY 188
LIST OF COLLECTIONS 189
INDEX 190

FOREWORD

The purpose of this book is to bring together into one volume a definitive selection of original sketches by "Special Artist" Alfred R. Waud made in the field during the American Civil War. These pages from his sketchbooks represent a small part of the collection of some 1150 such drawings by Alfred and his brother, William, now preserved in the Library of Congress; three sketches are reproduced through the courtesy of the M. & M. Karolik Collection in the Museum of Fine Arts, Boston.

While this volume is limited primarily to the works of Alfred R. Waud, undoubtedly the greatest of the Civil War combat artists, a sampling of William Waud's work is also included. Though he was not so famous or prolific as his brother, William Waud's drawings are no less well executed, and their historical value is equally deserving of attention.

Wherever possible the pictures are described in the artist's own words. Original spelling and punctuation are preserved.

A special thanks is due the late Malcolm F. J. Burns, maternal grandson of Alfred R. Waud, who generously contributed hitherto unpublished photographs, letters, news items, and memorabilia to the biographical section of this book.

During my years as art director of *Civil War Times Illustrated*, I have had occasion to study many of Waud's original sketches, acquiring an ever-growing admiration and appreciation for this artist's unique talent and for the often trying circumstances he must have encountered in exercising that talent. It is to be hoped that this collection of sketches and accompanying text will convey to the reader some measure of that respect and enjoyment.

<div align="right">Frederic E. Ray</div>

Part I

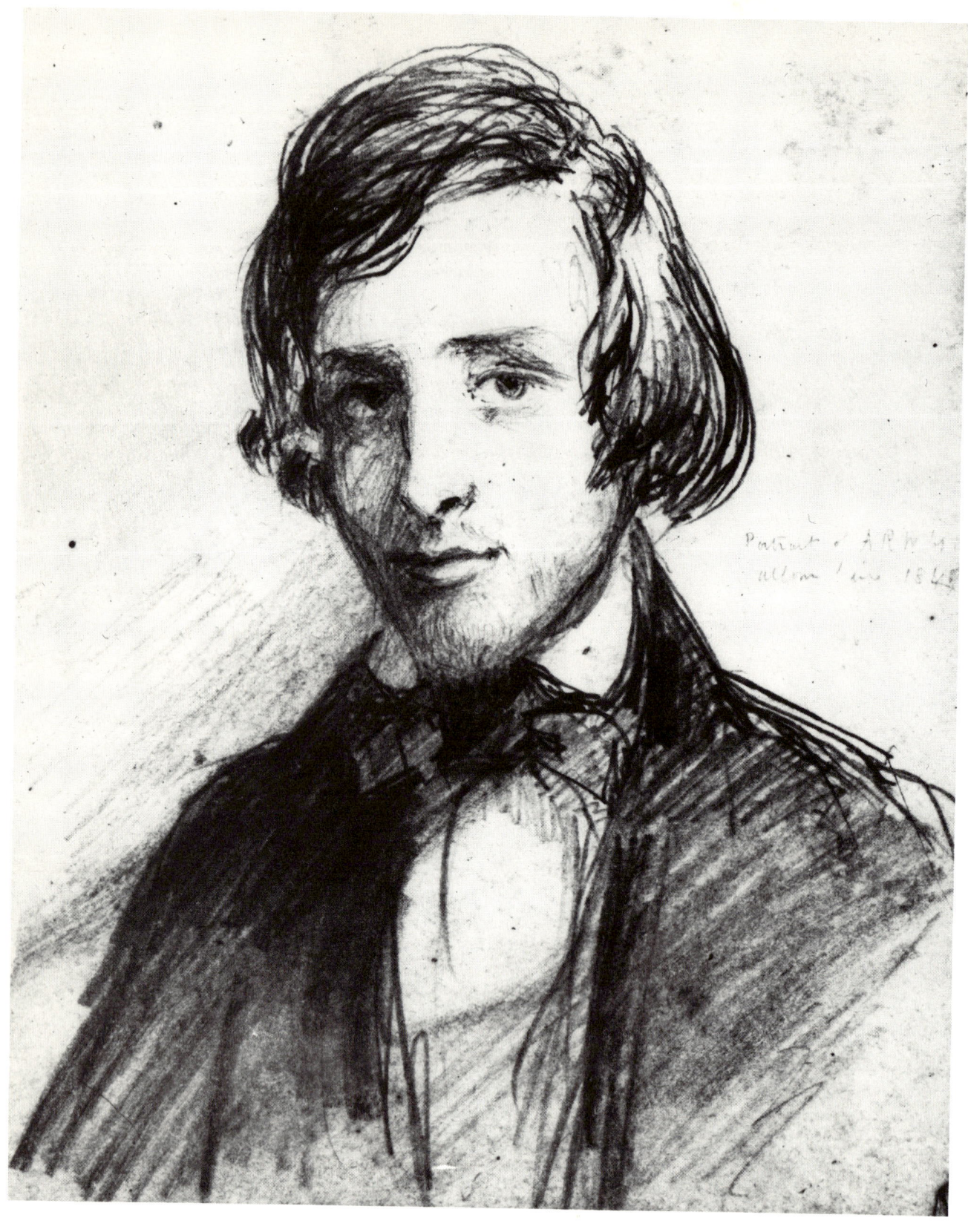

1. Pencil sketch of Alfred R. Waud at twenty-one made in England in 1849 by an artist friend, Arthur Allum. (Malcolm F. J. Burns Collection)

AN ARTIST GOES TO WAR

"There had galloped furiously by us, backward and forwards during our journey, a tall man, mounted on a taller horse. Blue-eyed, fair-bearded, strapping and stalwart, full of loud cheery laughs and comic songs, armed to the teeth, jack-booted, gauntleted, slouch-hatted, yet clad in the shooting-jacket of a civilian, I had puzzled myself many times during the afternoon and evening to know what manner of man this might inwardly be. He didn't look like an American; he was too well dressed to be a guerilla."

This colorful description was written by George Augustus Sala, a correspondent for the London *Daily Telegraph* who visited the Army of the Potomac in January 1864. His interest aroused, he did not let the matter rest there. His account continued:

> I found him out at last and struck up an alliance with him. The fair-bearded man was the "war-artist" of *Harper's Weekly*. He had been with the army of the Potomac, sketching, since its first organization, and doing for the principal pictorial journal of the United States, that which Mr. Frank Vizetelly, in the South, has done so admirably for the *Illustrated London News*. He had been in every advance, in every retreat, in every battle, and almost in every reconnaissance. He probably knew more about the several campaigns, the rights and wrongs of the several fights, the merits and demerits of the commanders, than two out of three wearers of generals' shoulder-straps. But he was a prudent man, who could keep his own counsel, and went on sketching. Hence he had become a universal favourite. Commanding officers were glad to welcome in their tents the genial companion who could sing and tell stories, and imitate all the trumpet and bugle-calls—who could transmit to posterity, through woodcuts, their features and their exploits—but who was not charged with the invidious mission of commenting in print on their performances. He had been offered, time after time, a staff appointment in the Federal service; and, indeed, as an aide-de-camp, or an assistant-quartermaster, his

minute knowledge of the theatre of war would have been invaluable. Often he had ventured beyond the picket-lines, and been chased by the guerillas; but the speed and mettle of his big brown steed had always enabled him to show these gentry a clean pair of heels. He was continually vaulting on this huge brown horse, and galloping off full split, like a Wild Horseman of the Prairie. The honours of the staff appointment he had civilly declined. The risk of being killed he did not seem to mind; but he had no relish for a possible captivity in the Libby or Castle Thunder. He was, indeed, an Englishman—English to the backbone; and kept his Foreign Office passport in a secure side-pocket, in case of urgent need.

This intriguing view of Waud is to be found in Sala's *My Diary in America in the Midst of War*, published in London in 1865. The "war artist," or to be more correct, the "Special Artist," described was Alfred R. Waud (pronounced Wode), the greatest of the Civil War combat artists who covered the war with sketch pad and pencil throughout the years 1861 to 1865—from Bull Run to Appomattox.

Alfred Rudolph Waud, born in London, England, October 2, 1828, was descended from an old Yorkshire family; the family name was originally Swiss and was spelled "Vaud." He was apprenticed in his youth to a decorator, but when he came of age he abandoned this occupation and began the study of art, for which he had shown considerable talent, at the School of Design at Somerset House, London. After some time spent as a scene painter for theaters, he decided to come to America, having, as he put it, "a sentimental liking for republican institutions." Waud landed in New York in 1850, carrying with him a letter of recommendation to John Brougham, popular Irish actor and playwright, who was then building the theater on Broadway afterward known as Brougham's Lyceum. As the playhouse was not to be finished for some months, and as there was no current work for a scene painter, the young Englishman, alone in a new country, was thrown upon his own devices. He worked at various jobs of an artistic nature, then went to Boston, where he learned to draw on wood blocks for engravers. The engraved wood block was at this time the most common method by which a drawing could be reproduced for mass circulation. He produced illustrations for various publications in Boston and New York during the 1850s, including work in Barnum and Beach's *Illustrated Weekly*.

Sketches of this period that survive, the earliest dated 1851, were made around Boston, New England, Washington, and New York. A ragged sketchbook of 1853 notes Waud's New York address as 290 Broadway, the first of several studio addresses he would later occupy on Broadway. A curious entry in the New York City Directory for 1854–1855 lists "Alfred R. Waudicus, draughtsman," at 218 Fulton Street, residence at Collins' Hotel. The entry is either a misprint or more likely a pseudonym under which he worked at the time. In the mid-1850s Waud married Mary Gertrude Jewett, and the first of four children, a daughter,[1] was born to them in Boston in 1856.

The earliest known book in which Alfred R. Waud's work appeared was a small

[1] Mary Waud, mother of Malcolm F. J. Burns. The other children were Selina, Alfred, and Edith Waud.

but ambitious publication, *Hunter's Panoramic Guide from Niagara to Quebec* by W. S. Hunter, Jr. It was published in Boston in 1857 by John P. Jewett & Co., which had originally published the highly successful *Uncle Tom's Cabin* by Harriet Beecher Stowe in 1852. *Hunter's Panoramic Guide* contained numerous drawings, minutely detailed in the style for which Waud was distinguished. An "aerial" panorama, seven and a half inches in width by *twelve feet in length*, folded into the book and traced the Niagara River from the falls to Lake Ontario, and the St. Lawrence River to Quebec—a considerable undertaking! It would seem probable that Waud must have journeyed along this route to make the sketches engraved in the book; such on-the-spot drawings were a forecast of things to come for the artist who would travel expansively in the coming years with pad and pencil.

A sketch of Washington Street, Boston, drawn about 1858, is preserved in the M. & M. Karolik Collection in the Museum of Fine Arts, Boston; it is a choice example of Waud's considerable ability for architectural delineation (Plate 1). A letter addressed to Waud from the Union Boat Club of Boston survives. It is dated March 19, 1860, and thanks the artist for the gift of a portrait of Coxswain A. Whitman, Jr., "with a background view on Charles River." The letter goes on: "All of us who have had the pleasure of a personal acquaintance remember with much satisfaction the hours which have been enlivened by your presence among us, and though deeply regretting your contemplated Spring removal to another city—nevertheless trust that in your future home all prosperity & happiness may ever attend you & yours." It was at this time (1860) that Waud accepted a position in New York as an illustrator with the *New York Illustrated News*.[2]

According to *American Artists and Their Work* (Boston, 1889), Alfred Waud's "original intention was to be a marine painter, to which end he devoted much serious study.... Waud's versatile and skilful hand has drawn many hundreds ... of illustrations, but it is never surer or more satisfactorily employed ... than when portraying some subject where ships and water make up the scene, whether in busy harbor or spreading bay, on river or open sea." His talent for drawing ships is evident in an early (1857) watercolor[3] of a seventy-four-gun ship making harbor, and he was obviously recognized by the *News* as the natural choice to sketch the U. S. sloop of war *Brooklyn* and views of United States ships, laying off the Battery in New York (Illustration II) and in the Charlestown Navy Yard, Boston, which appeared in the *News* in March 1861. These wood engravings were signed only "AW," and his drawing of the Washington Navy Yard (Plate 2), which appeared in April 1861, gives the artist no credit line at all.

[2] The *New York Illustrated News* was established in 1859 by John King, who sold the paper to T. B. Leggett in June 1861. W. Jennings Demorest purchased the *News* in January 1864, and the paper was renamed *Demorest's New York Illustrated News*. The paper did not survive the war; the last number was published on August 13, 1864.

[3] Malcolm F. J. Burns Collection.

With the outbreak of the Civil War in April 1861, the three leading illustrated weeklies, *Harper's Weekly, Frank Leslie's Illustrated Newspaper*, and the *New York Illustrated News* dispatched their "Special Artists" and "Special Correspondents" to cover the war fronts. In its May 4, 1861, issue the *News* announced: "We have made arrangements to obtain authentic sketches and information of the interesting and important events of the war. Alfred Waud, Esq., one of our most talented artists, and a special correspondent, will proceed to Washington, and will accompany the army through the campaign."

Waud and his party, after "innumberable difficulties in the way of passes," reached Perryville, Maryland, in crowded railroad cars. Here Waud made the first sketch of his wartime assignment. The fast-sailing ferryboat *Maryland* carried them to Annapolis, then under military rule, where fresh passports were obtained from General Benjamin F. Butler. The people of Annapolis, they observed, regarded them "with anything but the eye of affection . . . and generally looked sullen and ugly." They had a "miserable breakfast" and visited the old Statehouse before boarding the train for Washington. Once arrived in the capital, they found themselves "objects of attention" and "eager inquiries as to the news, and for papers not more than two weeks old, a total disarrangement of mail communication having placed Washington in a lamentable state of ignorance." The correspondents retired to their beds at Willard's Hotel to make up for three nights virtually without sleep.[4]

Shortly after his arrival in Washington, Waud was sketching Colonel Elmer E. Ellsworth's New York Fire Zouaves, lately arrived in the capital, as they successfully battled a blaze that endangered a section of Willard's Hotel on the night of May 9. The drawing was engraved in the *News* on May 25. Colonel Ellsworth would soon become one of the first famous casualties of the war, shot dead while hauling down a

[4] The *New York Illustrated News*, May 18, 1861, 26.

II. War had not yet broken out when Alfred Waud made this drawing. Engraving from the *New York Illustrated News,* March 30, 1861.

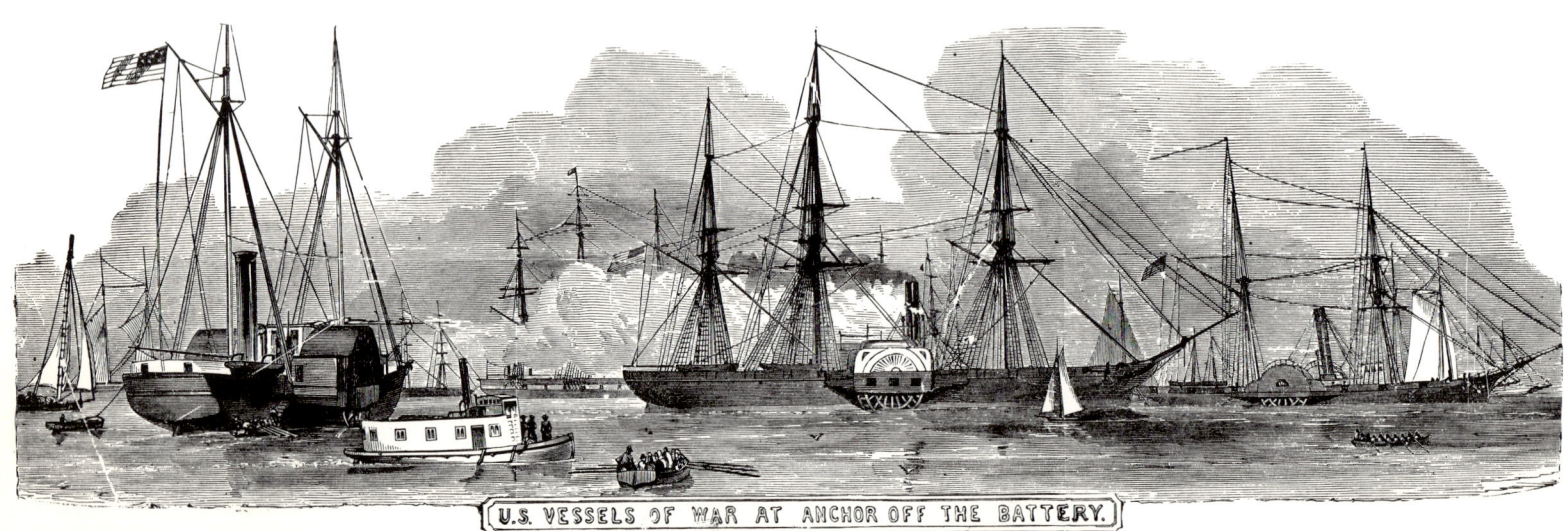

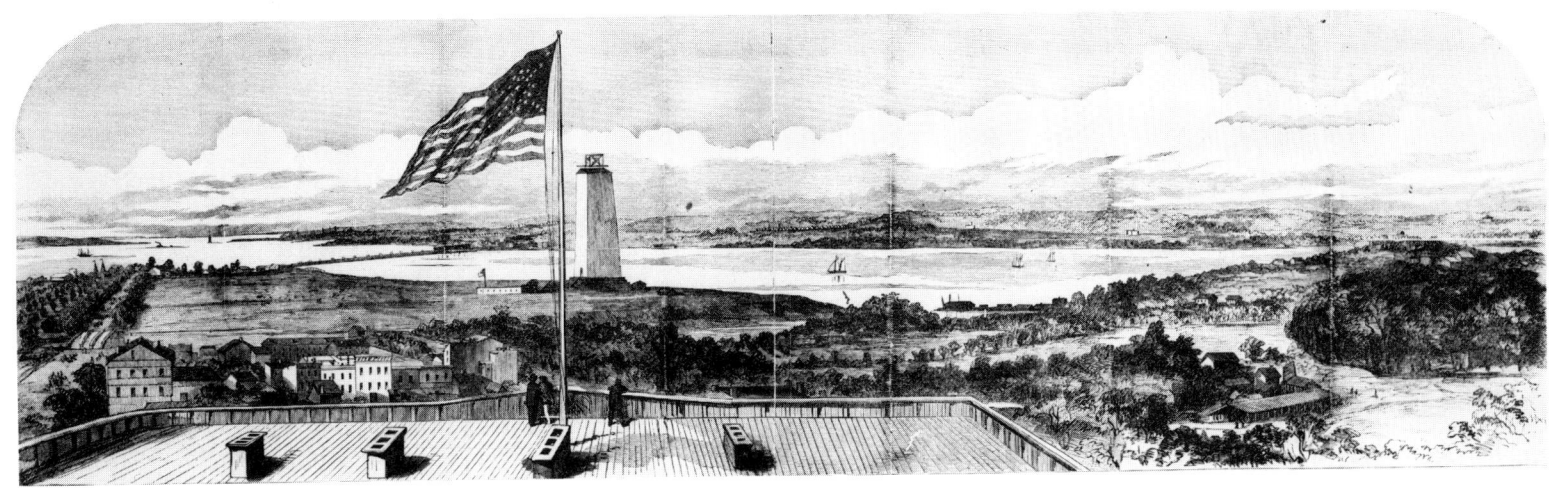

III. This view of the position of the Union army on the shores of the Potomac was sketched by Waud from the roof of Willard's Hotel shortly after his arrival in Washington and was engraved in the *New York Illustrated News*, June 29, 1861. The unfinished Washington Monument appears in the background.

rebel flag in Alexandria, Virginia, on May 24. Two days later Waud was on hand to sketch Ellsworth's funeral at the White House.

General Winfield Scott, then General-in-Chief of the army, seventy-five years old and a hero of the War of 1812 and the Mexican War, grudgingly consented to sit for Waud in his office (Plate 4). Waud wrote: "I had the honor of shaking hands with him and can safely say that his lion eye is still as imposing as ever, although he occasionally uses his spectacles."

On July 22, 1861, the day following the Union defeat at Bull Run, the *News* published Waud's description of an earlier encounter with a would-be horse thief near Alexandria, Virginia:

> On Friday morning I had a skirmish on my own account. A soldier wanted to get my horse from me, seized the snaffle rein, and stated that he had dispatches and was ordered to take the first horse he saw to get into town speedily, and invited me to give up quietly. I whipped the animal violently, dragged the man a short distance, when the rein gave out; he drew his revolver and threatened to fire if I did not stop; wheeling round I drew mine, under cover of my portfolio, cocked it, and then pointed it at him, with the remark that I should kill him if he presented his—he was holding it pointing at the ground, and was very unsteady from the excitement, (it was very hot,)—as I had the advantage, he returned it slowly to his belt, and I rode off devilish quick. I asked afterwards if it was likely he had such orders, and was told he doubtless took me for a citizen of Alexandria who could be bluffed off his horse, so that he (the soldier) might ride in instead of walking it.

William Waud, Alfred's younger brother, had trained as an architect in England, assisting Sir Joseph Paxton in the designing of the London Crystal Palace about 1851. In the mid-1850s he joined his brother in New York where he was listed in the New York City Directory for 1856–1857 as a draftsman residing at 132 Nassau Street. Both brothers apparently lived in Boston at the same time; William was listed in that city's directory from 1857 to 1859 as a "designer." And both men followed parallel careers;

IV. Waud embellished the masthead of the *New York Illustrated News* with this finely detailed drawing of New York Harbor. The work is signed "A. Waud" and by the engraver, "Anthony."

Alfred became a "Special Artist" for the *News*, William for *Leslie's*. But in contrast to his brother, William's wartime assignments for *Leslie's* took him far afield. In 1860 and 1861 he was sketching events in Charleston, South Carolina, Jefferson Davis's inauguration as President of the Confederacy in Montgomery, Alabama, and the bombardment of Fort Sumter in Charleston Harbor that plunged the nation into civil war—a scoop for *Leslie's*.

In 1862 William Waud was with Farragut's expedition against New Orleans; a self-portrait in *Leslie's*, May 31, 1862, showed him in a bowler hat "sketching the naval engagement between the Federal fleet and the Rebel forts, rams and gunboats, in the Mississippi River from the foretop of the U.S. War Steamer *Mississippi*" (Illustration V). He was still with *Leslie's* during the Peninsular campaign when he was felled by sunstroke and fever; in 1864 he joined the staff of *Harper's*, picturing the Petersburg campaign in company with his brother (Plate 74). He was soon back in the heart of the Confederacy sketching General Sherman in Savannah and following the Union army's drive through the Carolinas. A study of "Sherman Reviewing His Army in Savannah" (Plate 95) clearly shows William Waud's background in architectural drawing evidenced by his precise delineation of the buildings along Bay Street in that city. Following the assassination of President Lincoln in April 1865, he accompanied the Lincoln funeral train on its long journey back to Springfield, Illinois, sketching for *Harper's* scenes of the casket lying in state in Cleveland, Chicago, Springfield, and finally the burial of the martyred President.

Little is known of William Waud's life or work in the years following the war. *Harper's*, in announcing his death in Jersey City on November 10, 1878, stated that

V. William Waud portrayed himself in *Frank Leslie's Illustrated Newspaper*, May 31, 1862, "sketching the naval engagement between the Federal fleet and the Rebel forts, rams and gunboats, in the Mississippi River from the foretop of the U. S. War Steamer *Mississippi*." This is the only known likeness of William Waud.

he was not only an excellent artist but a gifted writer and architect as well. The Waud letters in the Library of Congress indicate a close relationship between the brothers. Three Waud sisters, with whom Alfred maintained a lifelong correspondence, remained in England and apparently never visited the United States.

In July 1861 General Irvin McDowell's Federal army began its much-heralded march on the Confederate capital at Richmond. "Alf" Waud, with reporter Richard C. McCormick and Edward House of the New York *Tribune*, accompanied the army in Mathew Brady's photographic wagon, which, hooded in black and presenting the appearance of a hearse, was dubbed the "what-is-it" wagon by the curious soldiers. Brady was, at the time, an eminently successful portrait photographer with studios in New York and Washington. He had financed his own venture into the field of war photography simply because, as he put it, "I felt that I had to go. A spirit in my feet said 'go' and I went." In time Waud would find occasion to make use of photographs in composing some of his sketches (Plates 48 and 68), and in his later years Waud himself became a competent photographer.

The fledgling armies of North and South clashed at Bull Run (Manassas) on July 21, 1861. It was a baptism of fire for Waud and for Dublin-born Arthur Lumley, *Leslie's* "Special Artist." Both sketched feverishly through the hot day's battle before being caught up in the headlong retreat of McDowell's army and a host of civilian "sight-seers." Waud was credited with a fruitless attempt to rally the fugitives. Brady barely saved his photographic plates, while Waud, in company with Edward House and Joe Glenn of the Cincinnati *Gazette*, reached Centreville, where, believing the Federal retreat would not likely extend beyond that point, they were soon asleep. In the morning they discovered Centreville deserted of Union troops who had fallen back all the way to Washington. The three made a hasty departure and, following in the wake of a demoralized army over some twenty miles of littered rain-swept roads, finally arrived in Washington, a city stunned by the magnitude of the Union defeat.

In the August 5, 1861, number of the *News* Waud's drawing of Colonel Corcoran's 69th New York (Irish) Regiment, stripped to the waist and charging with the bayonet against Confederate positions at Bull Run, appeared on the first page. The same issue carried his drawing of Colonel Ambrose E. Burnside's Brigade, the 1st and 2nd Rhode Island and the 71st New York regiments with their artillery attacking the rebel batteries (Plate 7). Waud included a self-portrait in another sketch of Sherman's battery in action at the commencement of the battle (Illustration VI). In the M. & M. Karolik Collection in the Museum of Fine Arts, Boston, there is a pencil sketch, very hurried, showing soldiers, civilians, and vehicles in headlong flight and is inscribed "Panic on the road between Bulls Run & Centreville." The picture is unsigned but is most likely by Waud; the inscription is definitely in his handwriting.

Bull Run was Alf Waud's initiation to the carnage of the battlefield, a confrontation that would become all too familiar while campaigning with the Army of the

Potomac during the following four years of war. He had not long to wait after Bull Run for his next taste of action. In August 1861 he joined General Benjamin F. Butler's expedition against Cape Hatteras, North Carolina. The Federal fleet sailed from Fortress Monroe, Virginia, and on August 28 began the bombardment of Confederate Forts Hatteras and Clark. Waud went ashore with the troops (Plates 8 and 9), and after the surrender of the forts the next day he sketched the captured earthworks. It was a brief affair, and he was soon back at Fortress Monroe. It was the only time during the war that he was to leave the Virginia theater of operations.

Following the debacle at Bull Run, President Lincoln appointed General George B. McClellan as the new commander of the Army of the Potomac. "Little Mac" would spend the next seven months whipping his vast army into a disciplined fighting force. For the artist in the field with the Army of the Potomac it was a period of

VI. Alfred Waud included a self-portrait in this picture engraved in the *New York Illustrated News*, July 29, 1861. The illustration was entitled: "Commencement of the Action at Bull's Run. Sherman's Battery of Rifled Cannon Engaging the Enemy's First Masked Battery. Sketched on the spot by A. Waud, Esq." The *News* reported that Brigadier General D. Tyler "is represented in the picture as he actually appeared on the field of battle, giving instructions. Our artist, Mr. Waud, is in the foreground, sketching the exciting scene." Note that Thomas Nast's signature appears on the engraving; Nast was undoubtedly the engraver and his frequent signing of Waud's pictures could account in part for Waud's dislike for him. (See Waud's letter to "Friend Paul" on page 35.)

waiting out the next major battle and contenting himself by sketching scenes of camp life, fortifications, military reviews, or an occasional scouting foray. During the autumn of 1861 Waud was especially active in the Fortress Monroe and Newport News area. His "Sketches in and Around Newport News" and "The Blockading Squadron at Anchor in Hampton Roads, off Fortress Monroe" appeared in handsome double-page spreads in September and October respectively; the latter drawing, in which the Federal warships are beautifully executed in exacting detail, once again points up Waud's avid interest in marine subjects for his sketchbook.

In its issue of September 23 the *News*, in describing Waud's drawing "Flag of Truce—Southerners Being Transferred to the Rebel Boats, Near Norfolk, Va.," mentioned "Our energetic special artist, Mr. Waud, who somehow or other gets a look

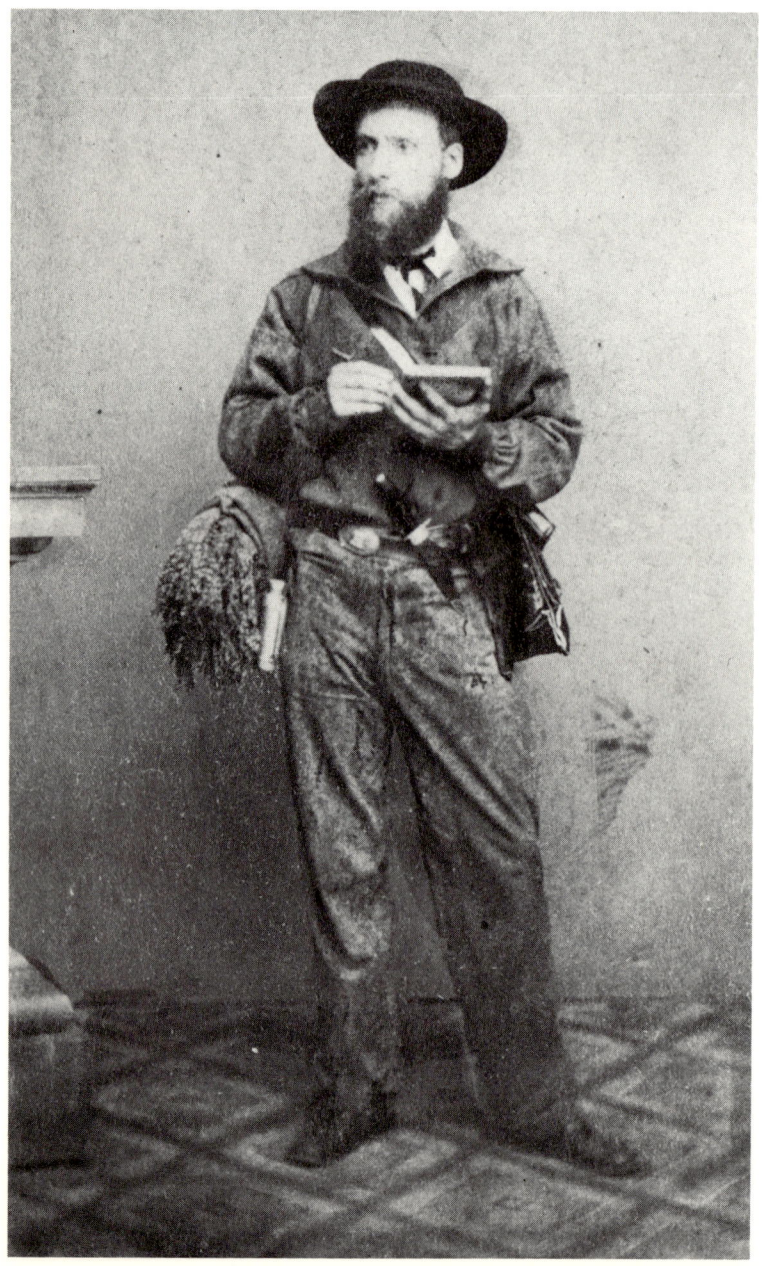

VII. This rare photograph of Waud was taken in Mathew Brady's Washington studio probably just before or after the First Battle of Bull Run, July 1861. Waud is seen here fully equipped for the field: sketchbook in hand, a bowie knife and a revolver at his belt, blanket roll hanging from his back, and a flask visible on his right hip. His haversack probably holds his artist's materials. (Malcolm F. J. Burns Collection)

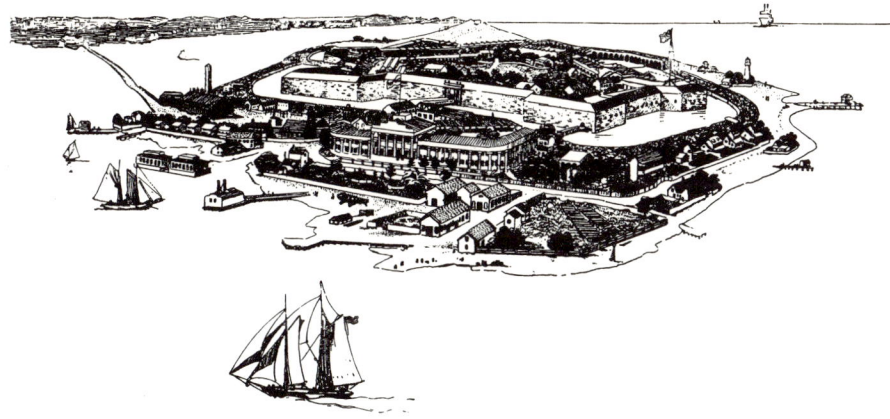

VIII. Fortress Monroe, Virginia, as it appeared during the Civil War. (From a drawing in *Battles and Leaders of the Civil War*)

at every thing, and is useful and agreeable everywhere, whether in an attempt to rally the fugitives at Bull Run, or in the more calm arrangements of a flag of truce, at Fort Monroe...."

(Waud's description of this incident accompanies his original sketch shown in Plate 10.)

On October 21, 1861, the *News* published a long article by Waud entitled "A Day in Camp With the Army of the Potomac," a colorful and detailed description of a morning with McClellan's army:

> Enjoying the hospitality of the Colonel's tent, I had been sleeping luxuriously upon a hospital stretcher, my head supported on a valise by way of pillow, when the trumpeters, devoting themselves with might and main to the reveille, utterly routed Morpheus. Looking from the open entrance, the soldiers are seen rushing from their tents and finishing dressing, as they receive the hot coffee, which in well regulated commands is given them to keep off the ill effects of the chill morning air, at this season never wholly free from malaria. Roll call follows, and the band assembles on the parade. Details from each company form upon the ground for guard mounting, and after going through sundry evolutions, are told off to relieve those who have been on guard the preceding twenty-four hours. The music is pleasantly prolonged, (I tremble when I think of an idiotic proposal to discharge the bands on the score of economy), and feeling no obligation to rise, I continue to enjoy my stretcher and look at things recumbently. And first this tent commands my admiration, it is spacious; and in the centre is a trophy formed of three gorgeous regimental flags, sundry sabres, sashes, caps, opera glasses, pistols, and red bunting, over all two rifles crossed, two others being also dependant at each end of the ridge pole. There are two tables garnished with books on military tactics, account books, reports, passes, &c.; any quantity of camp stools, with and without backs, washstand of primitive construction, the colonel's sleeping arrangement, from which he is already absent, though visible outside the tent giving instructions to an orderly while he rasps the water from his face with an awfully rough towel. Some boxes, a trunk, and a stand for saddles, cloaks, &c., complete the furniture, which is raised some six inches from the earth on a neat floor of boards.
>
> The rush of orderlies into the adjutant's tent—which is "next door"—to deliver the company reports, the rapid movements of the men, now engaged in battalion

21

drill, and, above all, the sudden appearance of the sun—imparting a dreadfully dissipated glow to the faces of the musicians, and the nose of the sentry outside the tent—overcomes me with a sense of the enormity of bed laziness. So having dressed and performed a pleasant toilet under the pine trees at the back of the tent, I am ready for breakfast, which is forthwith served in advance of the usual time, on one of the tables in the tent; beefsteak and potatoes, bread, poached eggs, pancakes and coffee, forming the bill of fare. Cigars follow, the colonel dives into business, reads reports, signs passes, gives orders, and dictates to his secretary.

More interesting are the proceedings outside. Two large armed working parties are on the march, fifteen hundred to one fort, and five hundred to another, to work on entrenchments, which, all things considered, they do with commendable cheerfulness. Another body of twenty men from each regiment, under command of an engineer officer, is departing in still another direction to work upon the neighboring roads. Besides these heavy details, between sixty and seventy men are sent to the quarters of the general of the division to be placed on guard for the protection of those houses not deserted by their inhabitants. Deserted dwellings, unless known to belong to Unionists (although that is not always a protection), are soon dismantled to aid in adorning and making more comfortable the tents in adjacent camps.

The prisoners, namely, those soldiers under punishment for offenses against discipline and order, are cleaning the camp, sweeping, shoveling, and removing in barrows the surface refuse, digging drains, &c., and at this sort of work they are employed from seven o'clock till noon, and from half-past one till six o'clock.

|The men having had breakfast, clean arms and accoutrements, and drill again for two or three hours. I stroll about the camp, which is pleasantly situated, and in good order. The main streets are on a level plateau alongside a railroad, up and down which a locomotive is constantly puffing with cars in tow, for conveyance of stores and men. It is the same train that carried the Ohio men into the ambuscade at Vienna.|

Most of the tents have additions in the shape of bough houses, which are pleasanter and more healthy resting places while the sun shines, than hot canvass can afford.

The horses, wagons, kitchens, quartermaster's stores, hospital, sutler, &c., all have appointed places.

From the body of the camp the regimental field and staff officers' quarters are separated by a little brook, crossed at intervals by rustic bridges, that give a scenic character to the spot. The brook is full of felled trees, and the precipitous bank at the back of the tents, some eighty or one hundred feet above another and a larger stream, is covered with a confusion of timber which has been cut down to clear the view. In the meadows beyond, infantry, cavalry and artillery are drilling by word and by the bugle, all day.

At twelve o'clock the dinner call is blown *con amore*, by a lanky bugler, who cracks frightfully on the three last notes, in his anxiety to finish and be off to his ration. Shortly after, dinner is announced in the mess tent, a spacious structure of the rustic order, with sides of cedar branches and roof of canvass. A gratifying smell of soup floats about, and the dinner, which reminds one of a pic-nic, is well served and most decidedly appreciated.

More drilling is done in the afternoon, and a dress parade is also accomplished. The working parties return, and if there is a necessity for great haste, other parties go out to continue the work through the night. And here I will express a regret at this necessary employment of so much of the time that is required to give the men

greater proficiency in drill. Long strings of horses are taken, raising clouds of dust, to the creek, where they are watered; one or two break loose and a grand scamper ensues after the runaways, giving an opportunity for harder riding than under ordinary circumstances is allowed. Standing near division headquarters, I watch the gradual approach of the wagon trains, rumbling noisily along into camp with loads of commissariat and quartermaster's stores and ammunition.

The gradual arrival of groups of officers, and the presence of the band in front of the General's quarters, proclaim the approach of the hour when the evening parade of officers is held. With an easy military air, free from the stiffness of a line parade, they form in front of his tent, occupying three sides of a square; the infantry in front and to the right, the artillery and cavalry on the left, before their horses.

The band plays a selection from "Robert le Diable," the officers chat and introduce one another; the rays of the setting sun slant glowingly upon the scene, and rosily tinge the distant woods and hills, dotted with tented towns, over which, crowning the heights, the red fortifications rear their cannon-crested bastions, and the smoke of a recent salute curls lazily about the flag-staff and floating off in orange and purple clouds. The echoes die away; and now the General, attended by his staff, comes forth from the rustic Gothic arches of cedar that enclose the space in front of his tent—a sort of open ante-room, giving an air of retirement to the inner quarters. Joining a group of field officers in the center of the parade ground, greetings are exchanged, and conversation, very often of an animated character, follows. The exact topic I cannot disclose for several reasons, the principle being, that ever in the character of a newspaper correspondent, it is not possible to pluck up assurance enough to approach so distinguished a party with the bare intent of eavesdropping.

Military brevity at any rate rules the proceedings, which are soon over; adieux are made, the countersign delivered in envelopes by an aid, and the band plays a lively march, the parade is broken up, and the ground gradually cleared of its late occupants. Some members of the Government who have been present, and officers of other divisions, accepting the General's invitation to his tent, retire there with him. I linger till the band has finished its last piece of music, and the moon having come up, I proceed, by means of a single rickety log across a little creek, in the direction of my friend's encampment. The way lies through a cavalry camp, you would know it by the smell, even if the horses were absent, of which you have abundant evidence that they are not, there being a constant thumping and neighing, owing doubtless to the fact of their having just returned from the watering-place, and therefore not had time to resume their normal condition of equine resignation. The not unwelcome supper-call invites to the mess tent, now lighted by Chinese lanterns of colored paper, and wax candles in candlesticks or bottles, around which various specimens of the entomology of the country, perform voluntary auto-da-fe. Eating over, those officers not on duty remain some time to smoke, maybe to dispose of a bottle of light wine, always provided the Provost Marshal has not so strictly exercised the right of search on the Long Bridge, as to have frustrated all attempt to smuggle over that fluid.

Out into the calm moonlight of this delicious Indian summer, among lines of tents, through whose canvass walls to which the lights inside give a dull glow, comes the sound of laughter and singing. Ah, this is the time to realize the poetry of the scene, common places hidden in the broad deep shadows, or lost in still broader fields of pure effulgence, no longer intrude themselves upon the attention. One scene in the romance of the army is before us, none the less enchanting, because a peaceful one. From the band, Schuberth's serenade floats dreamily, adding the only

charm wanting to the time, linking it with the other moonlit nights of past summers, on whose placid hours no thought of war intruded. The spell is of brief continuance, for from hill side and valley along the whole extent of our lines, bursts forth the music of innumerable military bands, playing marches, waltzes, overtures, and opera airs, according to the sweet fancy of the band masters, or by particular request of the commandants. Trumpets, bugles, drum and fifes, anon strike in, with a noisy selection of calls it being time for tattoo. The bands still struggle on with a universal predilection for the "Star Spangled Banner," till the signal is sounded for the extinguishing of lights. The tents lose their semi-transparency, and with the exception of the lamp in the guard tent, and another in that of the Colonel there is no opposition to the cold light of the moon, unless when the breeze wafts a shower of sparks from the decaying fire, by which a sentry leaning on his musket is waiting statue-like for the approaching relief.

As I am outside the lines, I receive a peremptory command to halt, to which the German sentinel bringing his piece to the charge, adds the usual: "Who goes there?" "A friend with the countersign" I answer. "Approach friend and give the countersign." Walking up to within six or seven feet of the man, who then repeats the order to halt, I lean towards the bayonet, and—overcoming a strong desire to say Pumpernickle—whisper "Anderson." "Countersign is right," says the sentry, "pass on."

About fifteen minutes later the Lieut. Colonel makes his appearance before the Colonel's tent, with some nine or ten others, not apparently in the same good spirits as their leader. It appears that the quartermaster of the regiment with some of his friends and other quartermasters, mostly Hebrews, had grown pot valiant and expressed anxiety to meet the enemy at any odds; the Lieut. Colonel, as officer of the day, readily acceded to their desire to accompany him on the grand rounds. Taking them on the outposts and giving them a wrong countersign, they were instructed to proceed, while he visited a point near by. Naturally the first guard they met, pronounced them imposters, and at once confined the poor quartermasters in the guard tent, not to be released till daylight. The Colonel having made his arrangements, came and let his quondam associates out however, and they continued the inspection till the heart of a thick wood was reached. In the middle of a dreadful anecdote of the ferocity of the rebels, and while contemplating the propriety of an immediate return to camp, bayonet and sabres gleamed around, and a savage voice ordered immediate surrender; at once the Colonel dashed away, calling all to charge and follow; this in view of the levelled pieces hardly seemed safe; so more dead than alive they dismounted, and were immediately disarmed and tied, their eyes at the same time being bandaged, and in this plight were hurried through close undergrowth, swamps, water courses, and fields of Indian corn, till worn out, they suddenly, and to their great relief, once more confronted the Colonel in company with their horses, on which one and all declared that they had seen through the joke from the very first, and in fact had been engaged in deceiving the Colonel the whole time.

After this, an occasional distant challenge from the guard, the drowsy hum and twitter of innumerable insects, and the footsteps of the sentinel in front of the tent, are the only sounds that reach me; these gradually seem subdued, the panorama in front of the open tent fades, and a day in camp is closed by the perfect repose that accompanies sleep in the open air.

ALF. WAUD

Waud was probably writing from the camp of General Louis Blenker's Brigade stationed near Washington. Blenker's camp was noted for its serenading bands. In *McClellan's Own Story*, published in 1887, the general wrote: "So far as 'the pride, pomp, and circumstance of glorious war' were concerned, it [Blenker's Brigade] outshone all the others. . . . The regiments were all foreign and mostly of Germans." (Note Waud's encounter with the German picket.)

In the same issue of the *News* that Waud's article "Day in Camp With the Army of the Potomac" appeared, his sketch of Fort Blenker in front of Blenker's Brigade was published, and in the September 23 issue of the *News* he illustrated and described "A Few Hours With Pickets" of Blenker's Brigade.

IX. "Rebel Horsemen Scouting Between Anandale [Annandale] and Fairfax" was the title of this sketch by Alfred Waud which appeared on the first page of the *New York Illustrated News*, December 28, 1861. It was one of his last drawings for that periodical before he joined the staff of *Harper's Weekly*. Note that the artist has portrayed himself crouching behind the cordwood.

The December 9 issue of the *News* presented what was claimed to be the largest wood engraving ever produced in the United States. It was Waud's drawing of "The Grand Review of 70,000 Troops of the Army of the Potomac by Geo. B. McClellan, Major General Commanding United States Army." It folded into five sections and was engraved (and signed) by Thomas Nast.

Waud's word description of a scouting mission, pictured in the previous number of the paper (Illustration IX), was carried in the January 4, 1862, issue of the *News*. By the time the following account appeared, Waud had already left the *News* and had joined the staff of *Harper's Weekly*:

> Having heard that the rebel pickets usually made a grand scout when going off guard duty, I accepted the invitation of a young officer of the Garibaldi Guard to accompany him to a point from which we should be very likely to get a good view of them. As it was over a mile from our lines, a little circumspection was necessary to reach our eyrie, a nook in the woods, close to the road, and among any quantity of cordwood.
>
> Soon after sunrise, our hopes were rewarded, first by the sound of hoofs, and then by the appearance of about two hundred men, with carbines and rifles ready for immediate use. They went by at a moderate canter, and carefully glancing from right to left. The Garibaldini could hardly restrain a reckless desire to fire on them. If there had been a couple of dozen there they would, I am convinced, have let fly; but four of us, all told, were scarcely justified in making an attack on two companies.
>
> Although pretty close, we were not near enough to observe the details of their equipments. They looked no worse clad than many of our own volunteers.

In September 1862 Waud would have his chance to see the enemy firsthand when he was "detained" behind Confederate lines, affording him the opportunity to sketch for *Harper's* rebel cavalrymen at close range (Plate 31).

THE "SPECIALS"

When Alf Waud joined *Harper's Weekly* in late 1861, that publication was already a flourishing periodical with a circulation of 120,000 copies weekly. Established in 1857 by the publishing firm of Harper & Brothers, the weekly's guiding hand was Fletcher Harper, the youngest of the four Harper brothers. Waud may have become disaffected during his later association with the *News*, or, more likely, he had received a lucrative inducement from Fletcher Harper to part company with his former employer. His connection with *Harper's* was to prove providential; he would contribute his talents regularly to that publication until 1870. His last drawing in the *News* appeared on February 1, 1862; his first credited illustration for *Harper's*, depicting a reception at the White House, was engraved in the January 28, 1862, issue (Plate 14).

Among other "Special Artists" of note working for *Harper's* was young Theodore R. Davis, the only artist with Sherman during the Atlanta campaign in 1864. Both Davis and Waud would find far-flung assignments with *Harper's* after the war.

Harper's closest competitor during the war years was *Frank Leslie's Illustrated Newspaper*, established in 1855 by Frank Leslie, an Englishman, and until the emergence of *Harper's Weekly*, two years later, was the most popular illustrated periodical in the country. As early as June 1861 *Leslie's* reported that they were receiving by express between twenty and forty sketches per day from their artists in the field and boasted that *Frank Leslie's Illustrated Newspaper* carried the "only correct and authentic pictorial illustrations of the war." Alf Waud's counterpart on *Leslie's* staff of war artists was Edwin Forbes, a better figure and animal artist than Waud with a finished drawing, but in the "short hand" sketches of battle action never Waud's equal. Others of *Leslie's* staff who did creditable work throughout the war were Arthur Lumley and Henri Lovie; the latter scooped *Harper's* with his dramatic pictures of the Battle of Shiloh for *Leslie's* in April 1862. Fred B. Schell, another of *Leslie's* artists, became a lifelong friend of Waud and in 1889 reported as head of *Harper's* art department.

Once the "Special Artist" had completed his sketch in the field, it was rushed by mail or courier, either overland or by ship, depending upon the location of the theater of war, to offices of the illustrated weeklies in New York. There a staff of engravers

laboriously copied the drawings on boxwood blocks, several engravers often working on the same picture, one man specializing on background, another on figures and other details. The wood blocks, once finished, were bolted together to form a completed picture, taking as many as forty blocks for a double-page spread. An electrotyped metal impression was made for printing on the rotary presses that poured out more than 100,000 copies of the papers each week. From sketch pad to printed page often took from three to four weeks. The woodcut reproductions generally failed to do justice to the originals, taking on a crude and stilted appearance and losing all resemblance to the artists' individual styles. Many were, however, copied with commendable accuracy and faithfulness to the original.[5]

In *American Art and American Art Collections*, edited by Walter Montgomery and published in Boston in 1889, Harry V. Barnett wrote of the "Special Artist":

> When you consider his work and his peculiar difficulties, you must admit that he is at least as remarkable a person as the Special Correspondent. I, for one, go so far as to say that he is by far the more astonishing character of the two . . . I can say, in fact, as one who has done both, that under the pressure of time it is much less difficult to write a column or so of fairly accurate and picturesque description, than to make a comprehensible sketch of a scene which may have existed only for a few minutes. It may be laid down as a journalistic axiom that it is easier to describe with the pen than to delineate with the pencil . . .
>
> A special artist need not be a great colorist, nor a first-rate draughtsman. If he is both, all the better, of course; but they are not essential attributes. What is absolutely necessary is that he should sketch both rapidly and accurately. They who can do this are few; so that a first-rate Special Artist is a joy to his employer for as long as he can keep him. . . .
>
> If he cannot paint great pictures, he must at least be able to see them; to see, that is, the picturesque essentials of the scenes or incidents he is employed to sketch. In short, he must be able to do more than merely draw outlines swiftly and accurately; he must be at least an artist in the best sense of the word,—a man whose mind is not only open to various and broad impressions, but also stored with knowledge and strengthened by experience. He must be gifted in some measure with the rare quality, imagination,—by which I do not mean the power of picturing the impossible, but the power of investing bare facts with charm, and vivifying them with spirit. . . .

The *News*, on June 7, 1862, reminded its readers of the attributes of the "Special Artists": "Their duty calls them into all sorts of dangerous places, and professional rivalry, and the eagerness to obtain news "exclusive" and in advance of the correspondents of other journals, keeps them constantly in the advance, and on that dangerous and disputed ground that has not yet been made safe by the onward march of our soldiers."

[5] Almost anyone with a knack for drawing could submit pictures to the illustrated weeklies during the war. The *News* published the following notice on June 15, 1861: "Notice to artists, reporters, soldiers and others. Any one, in any part of the country, who will send us faithful sketches of scenes and incidents connected with the war, however roughly they may be drawn, will be thanked by the proprietors of this paper. If the sketches be used, they will be liberally paid for."

Official indifference in which the "Specials" were sometimes held was commented upon by William Waud in describing the conditions under which he and a correspondent friend lived while with Farragut's expedition against New Orleans. In *Leslie's*, May 17, 1862, he wrote:

> The correspondent of the Boston *Journal* and myself are ashore in a cottage at Pilottown, of which I send you a sketch. We were only able to buy the fag-ends of the sutler's stores on board ship—no flour, or sugar, or meal, only preserved meats and "stuff" that needs no cooking. Our diet therefore is simple, if not cheap, consisting of hard ship bisquit—which we beg of the marines opposite—harder salt tongue, and coffee without milk or sugar. Add to this . . . that our sleeping arrangements imply no blankets, which I neglected to bring and which I cannot buy; imagine all this and more, and you will form some notion of the delights of a "Special Artist" off the mouth of the Mississippi. But they say there are "good things" in New Orleans, notwithstanding the blockade, whereof your "Special" hopeth to partake right speedily —and *will*.

Enemy fire was accepted by the "Special Artist" in the field as a normal hazard of his profession. Alf Waud wrote in *Harper's*, October 3, 1863:

> Culpepper Friday Sept. 18
> Your artist was the only person connected with newspapers permitted to go upon the recent advance to the Rapidan. An order of General Meade's sent all the reporters back. It was a very wet and uncomfortable trip part of the time. I did not get dry for two days; and was shot at into the bargain, at Raccoon Ford, where I unconsciously left the cover and became a target for about twenty sharp-shooters. Luckily I was not touched; but I did some tall riding to get out of the way. We have doubt here whether we shall advance further. Meade keeps his own counsel; but the general idea is against moving further on this line.

And one of Waud's sketches made in front of Petersburg the following year is notated: "This sketch was made at the request of General Meade, for his use—from a tree used by the Signal officers. It took over an hour and a half—rebel sharp-shooters kept up a fire at me the whole time." A news item published in 1864 during the Petersburg campaign noted:

> Two of Harper's artists, Alfred and William Waud, are with the Army of the Potomac, in front of Petersburgh, and another, Mr. Davis, is with Sherman. Mr. Alfred Waud has been with the army ever since the first battle of Bull Run, and is as well known throughout the camp as General Grant himself. He has been present at, and recorded with his pencil, every great battle in which the Potomac army has been engaged; in some cases cooly making his sketches under fire, whilst the enemy's bullets were kicking up little columns of dust on the ground around him. His numerous adventures and narrow escapes would fill a volume.

After the war Theodore R. Davis wrote the following reminiscence of Waud on the battlefield:

> As I write, my mind reverts to the old campaigning days with the army, and a story of an artist friend comes, as if to illustrate what I wish to show—how much glory a special artist would have had placed to his credit if he had stopped, fatally to himself, one of the many missiles used by the "Wayward Sisters' " relations when they

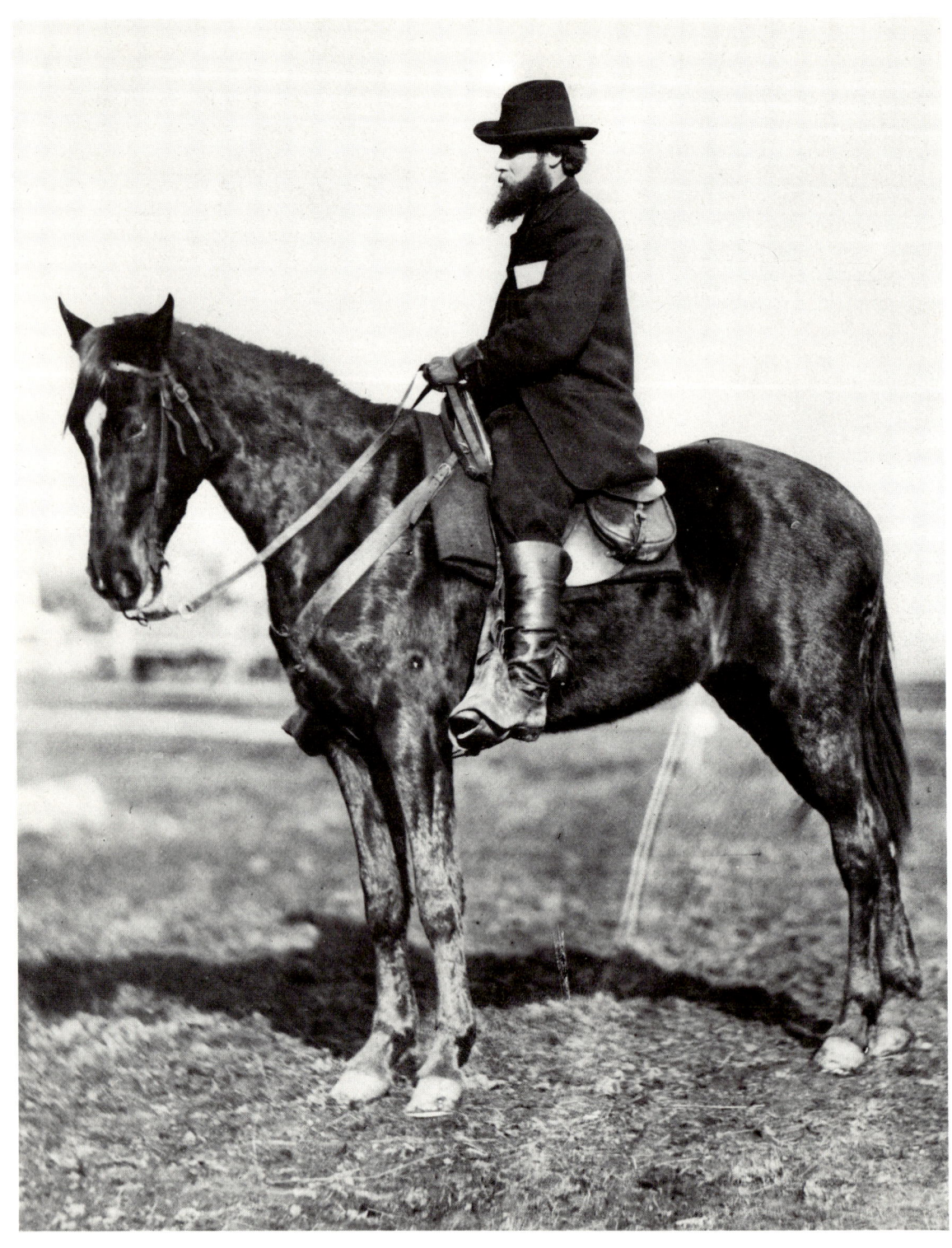

X. Mounted on "his big brown steed," Alfred Waud posed for the camera of James Gardner at headquarters, Army of the Potomac, in February 1864. He appears here much as George Augustus Sala described him on page 11. (Collection of the Library of Congress)

undertook to oust Uncle Sam from a large portion of his farm. "Waud," said General Wright, as the picture-seeking A. R. came up to a knoll which a number of general officers had occupied for the purpose of seeing and directing a battle going on some hundreds of yards in front, "you must get off that horse or else move away; you will draw fire over here, and there is quite enough of it already." "Good day, gentlemen," quoth Waud, as he galloped off to the line of battle in front; where, remarks the special, "it took me just next to no time to get all the sketch that I cared for, but it was all that I needed, and two days afterward some of those same general officers were anxious to know why I did not stay down with the line of battle longer." "What did you tell him Waud?" "The truth, of course; told these button wearers that had they been in my place they would not have gone there to begin with."

Considering the risks and discomfiture of the Civil War combat artist, the pay was, by present standards, meager to say the least—five dollars to twenty-five dollars per picture; Waud was probably working on salary rather than being paid by the drawing. The American Civil War was remarkably well recorded by the camera, employing at that period the wet collodion plate. A portable darkroom on wheels was needed for immediate development of the glass plates after a time exposure. Mathew B. Brady, Alexander Gardner, Timothy H. O'Sullivan, and George N. Barnard have left an invaluable record of still-life pictures, many of extraordinary clarity, but the images were, of necessity, frozen ones. The invention of halftone newspaper reproductions of photographs still lay far in the future, and it was left to the "Special Artist" with his sketch pad, seated at some vantage point during the battle, sometimes with field glasses trained on massed troop formations, to record the action of war—the charging regiments, plunging horses, the smoke and fire of battle or the disorder of a retreat. It remained for the artist with his pencil and the engraver with his wood blocks to bring the visual news of the war to the anxious firesides of the North.

The most outspoken critics of the art pouring from the presses of the illustrated weeklies were the soldiers themselves, who scanned the newspapers with discriminating eyes and expressed outspoken judgments. Young Lieutenant Oliver Wendell Holmes wrote to his parents to save "some daily record of this campaign & also a pictorial. Waud is quite a truthful draughtsman." And Sergeant William Peacock of the 5th Massachusetts Battery wrote home from Rappahannock Station in 1864: "Thinking you would like to see a picture of the Hill and River at this point I enclose one taken from Harper's [Waud's drawing "Capture by Sedgwick's Corps of the Rebel Works on the Rappahannock near the Railway Bridge," which appeared on November 28, 1863]. I consider this a very correct cut. I had a good view of our infantry as they charged the rifle pit, and this looks very much like it. . . ."

Harper's "Special," Theodore R. Davis, writing under the nom de plume "Croquis" in the New York *Evening Mail* in 1868, summed up the life of the "Special Artists" of the Civil War and focused on the reputation of Alf Waud:

Let me first attempt the description of the duties of a special artist—I say attempt, for though I write as one who may speak, as it were "by the card," I do not think that it is quite possible to convey the whole idea of those same duties in the amount of matter which THE MAIL will willingly transmit for me.

Total disregard for personal safety and comfort; an owl-like propensity to sit up all night and a hawky style of vigilance during the day; capacity for going on short food; willingness to ride any number of miles horseback for just one sketch, which might have to be finished at night by no better light than that of a fire—this may give an inkling of some of it, and will, I trust, be sufficient to convince my MAIL readers that the frequently supposed mythical special was occasionally "on the spot."

A. R. Waud and "Croquis" were the only two special artists who remained on duty during the entire continuance of the war.

Mr. Waud's labors were confined entirely to the Army of the Potomac, where he made for himself a reputation, and became recognized as the best special artist in the field. His collection of sketches is by far the most complete and valuable made during the war, that is, so far as the Army of the Potomac is concerned. At the close of the rebellion Mr. Waud made an extended tour through the Southern States, furnishing to *Harper's Weekly* a series of the most interesting sketches ever published by that journal.

The Waud Collection, a national treasure now preserved in the Library of Congress, was originally in the possession of Alfred Waud's daughter, Mary (Mrs. Milton J. Burns), and was purchased by Harper & Brothers in 1912. In 1918 the sketches were presented to the Library of Congress as a part of the J. Pierpont Morgan Collection. The drawings, rendered in pencil and sometimes in washes of black and Chinese white, are executed on toned paper, gray-green, brown, or tan, which allowed for emphasis with the opaque (Chinese) white. They range in various sizes, some finely detailed, others hasty "short-hand" sketches made in the heat of battle, such as the picture of Stevens' battery at Gettysburg.

YORKTOWN TO APPOMATTOX

On February 22, 1862, Alf Waud, now a *Harper's* "Special," was on hand to sketch the celebration of Washington's birthday and the presentation of captured Confederate flags in the old House of Representatives.[6] A host of government and military dignitaries was on hand, and "the galleries were densely crowded with well-dressed ladies and men." Waud's resultant sketch, "Rebel Flags in the Old House of Representatives at Washington," was published in *Harper's* on March 8.

While concentrating his army at Fairfax Court House, Virginia, in March 1862, McClellan received word that the Confederates had withdrawn from the Manassas line, which they had held since Bull Run, and had retired to new positions on the south bank of the Rappahannock. The newspaper correspondents with the army, thus cheated of an expected battle, converged upon the deserted rebel fortifications at Manassas. *The New York Times* correspondent reported:

> It was a sight to see the independent journalists when they rode away from the deserted rebel camp. Many with muskets slung over their shoulders and knapsacks to their backs, all with pockets distended and sides laden with all manner of secession trophies. The artist of "Harper's" [Waud] was enveloped in a red shirt and in his hand bore a lance of the rebel cavalry with the *guidon* attached. (*The New York Times,* March 14–15, 1862)

Shortly after the scene described above, *Harper's,* in its March 29 number, noted briefly: "Mr. Waud will continue to accompany the army under General McClellan, and will illustrate every event of note for *Harper's Weekly.*"

By the end of March McClellan's vast army was poised on the tip of the James Peninsula at Yorktown ready to move against the Confederate capital at Richmond.

[6] Waud's own pass to the old House of Representatives is preserved and reads: "Pass bearer to the front seat sofa next the Soldier's Gallery east side of Reporters Gallery."

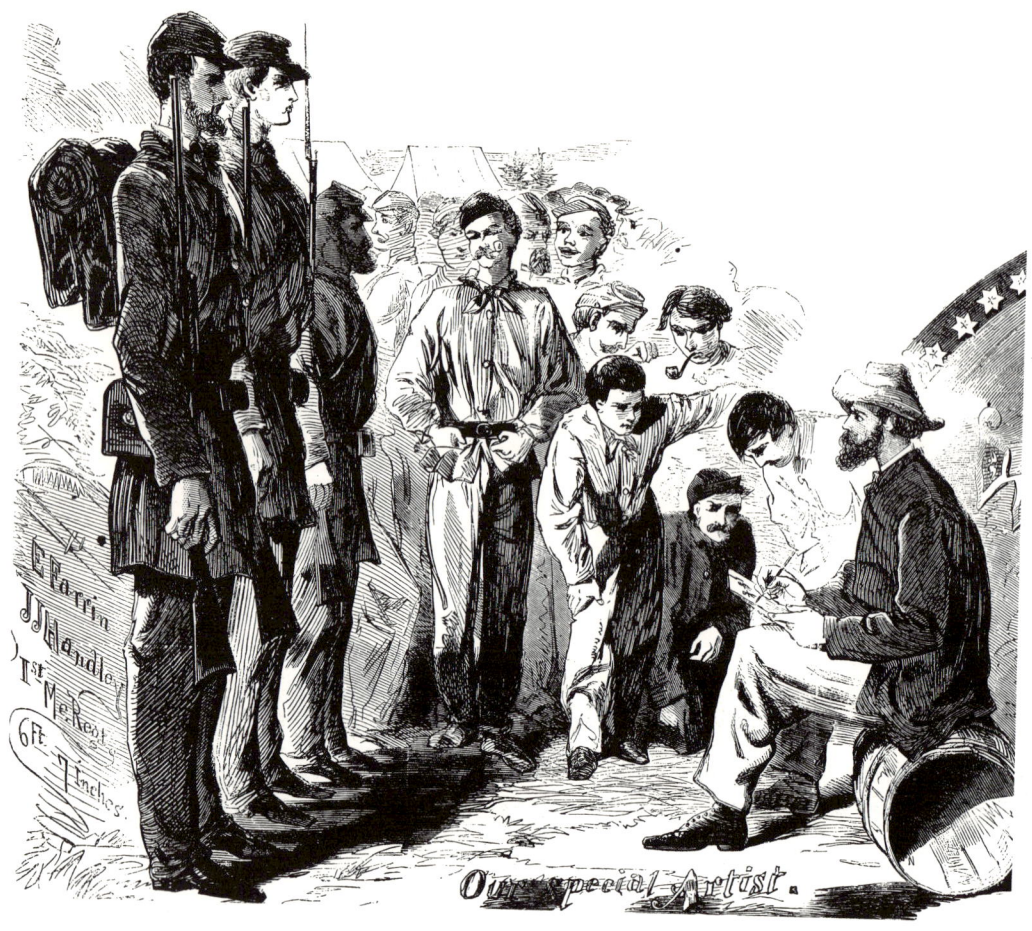

XI. Winslow Homer made this sketch of "Our Special Artist" seated on a barrel and surrounded by a crowd of curious onlookers as he sketches two six-foot-seven-inch giants of the 1st Maine Regiment. The "Special" is most likely Alf Waud, who was teamed briefly with Homer during the Yorktown campaign. The sketch appeared in *Harper's Weekly*, June 14, 1862.

During the ensuing Yorktown campaign Alf Waud was teamed with *Harper's* twenty-six-year-old Winslow Homer in making field sketches. *Harper's* of May 3 published a double page of sketches attributed to "Mr. A. R. Waud and W. Homer," and in the June 14 issue a drawing by Homer depicted "Our Special Artist" sketching two six-foot-seven-inch giants of the 1st Maine Regiment (Illustration XI). "Our Special Artist" is most certainly Alf Waud, although he was not otherwise identified. Homer, unlike Waud, was only infrequently in the field and then only for short periods. Most of his battlefield drawings were executed in his New York studio.

The Seven Days' battles around Richmond found Alf Waud and his brother Will (then with *Leslie's*) sharing in the miseries of McClellan's army on the Peninsula. Waud's quick, darting sketches of the fighting during June were made under severe stress. In a letter [7] from Camp Lincoln on the James River, July 5, he wrote:

[7] Miscellaneous Manuscripts Collection, Library of Congress.

Friend Paul: [8]

I have only just got your letter of inquiry about Will. When he got down here our line was long and there was little doing, also, anything occurring at one end of the position would not be known for some time at the other. Therefore you see it was very difficult to keep the run of events—and Will had no acquaintance of any value in the army. He made sketches and forwarded them of what subjects I do not know as about this time I was down with an attack of the billious remittent fever brought on by exposure to the damned climate in cussed swamps &c. For a month I could scarcely crawl dosed with mercury quinine iron whiskey &c till I have learned to hate that fluid and cannot smoke without nausea. However I am well and almost as strong as before in which I am lucky, as numbers of the soldiers have died of the same fever. To return to Will—three weeks ago he had a sunstroke and fell insensible to the ground while visiting Sickles Brigade. Since that time he has been sick, a low fever having used him up—a bad thing to have—(I can tell you—) a week ago to be sick, was to fall into the hands of the enemy. Will talks of coming home soon, to save his health although he is better than he has been.

To tell the truth, no amount of money can pay a man for going through what we have had to suffer lately, and being to my great astonishment alive, I feel a good deal like leaving myself.

The government by wickedly withholding the reinforcements which little Mac has requred for two months, has almost caused the annihilation of this army. The enemy almost surrounded us two or three to one on the Chickahominy and the only chance left us was to fight our way to the James river and the protection of our gun boats. For seven days against immense odds this gallant Army has fought like heroes, covering the retreat of the baggage trains, and rolling back the devilish grey coats—in every attack. Only think of it, seven days almost without food or sleep, night and day being attacked by overwhelming masses of infuriated rebels thundering at us from all sides, and finally securing our position, utterly worn out, in a drenching rain, with a loss of nearly 35 000 men 80 pieces of artillery and 300 wagons destroyed to keep them out of the enemies hands. So dogged have our men fought that the enemies loss foots up to a much higher figure than ours. At the last day's fight [9] they made sure they had us, but with such fury did our soldiers stand at bay that 10 000 of the rebels fell and our loss was but 1000. . . .

I envy you your quiet jog plenty to eat and drink and no risk from damned shells and bullets. I heard Nast [10] was with you. Between you and I, I detest him. Give my remembrance to all friends. I have been told Sol [11] is down upon me. I never meant

[8] "Friend Paul" was possibly Edward A. Paul, cavalry correspondent for *The New York Times*. The artists of the illustrated weeklies frequently accompanied the journalists of the national newspapers in the field.

[9] The Battle of Malvern Hill, fought on July 1, 1862 (Plate 27).

[10] Thomas Nast had been on the staff of the *News* where he had prepared Waud's field sketches for publication. He joined *Harper's* soon after Waud in 1862. The latter's dislike for him possibly stemmed from his tampering with Waud's sketches and consistently signing his name to Waud's drawings engraved in the *News*. Theodore R. Davis, writing in 1868, said of Nast: "It was Thomas Nast's province during the late war to make for himself the reputation of a war artist, without the unpleasant necessity of exposing himself either to the hardships of campaign life or the dangers of the battle-field. Some of his illustrations, published in *Harper's Weekly*, were good and to a certain extent truthful, for Mr. Nast is a careful observer and noted closely the sketches and photographs of campaign and battle incidents, to which he had access; but in some of his pictures, the oldest veteran would fail to discover anything the original of which he had ever seen except in one of Mr. Nast's own pictures." Nast would become *Harper's* most famous political cartoonist in the postwar years.

[11] Sol Eytinge, an artist-engraver at *Harper's* (see page 58).

to give him offence and do not understand how I have—however, can't stop for that as we say in the army.

Where I write this, the woods where the enemy is ensconced are in full view separated from our position by corn and wheat fields. All along our line I see batteries in position ready to repel any attack. Franklins [12] balloon is up in the air watching the rebs, and the advance camps of the infantry dot the fields with their little shelter tents. Our army is in excellent spirits, and the bands, not allowed to play before Richmond are in full blast again forges are at work—infantry reliefs going out on picket, or to cut down the woods to form abattis in front, strings of artillery horses going to water, men building bowers for shade cooking progressing in all directions, wagons moving up and down from the river with commissary stores for the soldiers every thing orderly and ship shape again. . . .

Waud's estimate of the size of the Confederate army in the Seven Days' fighting was understandably exaggerated. The Union army actually outnumbered the Confederate forces on the Peninsula, but McClellan himself was firmly convinced that he faced an overwhelming enemy.

Describing a bayonet charge of the Second Excelsior Regiment at Fair Oaks, Waud wrote in *Harper's,* August 16, 1862:

I send this under the direction of General Sickles and Colonel Hall (his was the only regiment of the Excelsior Brigade that charged). The locality is correct. The line of men is correct, and the enemy's skirmishers as Hall found them. No hand-to-hand desperate work by demoniac individuals in Zouave dress and caps—the Excelsior Brigade wears the infantry uniform with felt hats. *I could not send this at the time as I was flat on my back.* [Italics mine.]

In spite of such incapacitation, Waud managed to execute a number of dramatic sketches of the ill-fated Peninsular campaign. (Plates 19 through 28) He was back on the old Bull Run battlefield on August 30, 1862, to record yet another Union defeat, producing a sketch of the 11th Corps "disgracefully running away" as he noted in his sketchbook (Plate 29).

In the autumn of 1862 Lee's Army of Northern Virginia invaded Maryland. McClellan's pursuing forces fought their way through the contested passes of South Mountain (September 15, 1862), where Waud depicted Franklin's Corps storming Crampton's Gap and noted that "the corps covered itself with glory." Thirty-four years later Waud's name would be inscribed on the War Correspondents Memorial Arch at Crampton's Gap, erected by journalist George Alfred Townsend.

The Maryland campaign culminated in the Battle of Antietam on September 17, and Alf Waud's pencil was busy recording this single bloodiest day of the war (Plates 32 and 33). His sketch of an amputation after the battle graphically showed the raw stump of an amputated leg. Probably out of consideration for the more delicate sensibilities of its readers, *Harper's* engraved the same scene in its October 11 issue showing the wounded soldier turned around and the gory process of amputation discreetly hidden (Plates 34 and 35).

[12] General William Buel Franklin, commanding the VI Corps, Army of the Potomac.

XII. Alfred Waud seated in the ruins of the Norfolk Navy Yard shortly after that city was recaptured by Federal forces in May 1862. (Negative by Timothy H. O'Sullivan; positive by Alexander Gardner.) Waud wrote on his own print of this picture: "Pendant to Marius in Carthage," a reference to Caius Marius, Roman soldier and consul, who, in flight from his political enemies, landed in Carthage where he received a message from the Roman praetor ordering him to leave the country. Marius sent the reply: "Tell the praetor that you have seen Caius Marius a fugitive sitting on the ruins of Carthage." (Collection of the Library of Congress)

Seven of Waud's drawings of Antietam were engraved in the October 11, 1862, number of *Harper's*. In describing a sketch of the First Maryland Battery in action during the battle, he reported his impressions of the carnage:

> ... This battery was raised in Baltimore, and is armed with eight rifled light 3-inch guns. In the picture it occupies the ground upon which one of the rebel division lines was formed, the dead lying so thick as to mark distinctly their position right across the fields. On the right is a church [the Dunker Church] on the edge of the rebel position in the woods. Around this building the loss of life was enormous, the little road in front being filled (as well as the adjacent fields) with corpses. Toward the centre of the sketch is a corn-field and orchard, where there was some awful fighting, the dead lying piled up in groups. . . .

Commenting upon a drawing of the flight of the inhabitants of Sharpsburg, he wrote:

> Sharpsburg contains a population of about 2000, mostly Union people, the exceptions being very few. It suffered considerably in the recent battle, several buildings being burned, one of them being destroyed by the carelessness of the rebel soldiers who were cooking in it. All that was eatable they ate up; blankets they stole, and furniture they destroyed, even digging up things which the inhabitants had *cached*. Most of the citizens left the town with the women and children, hiding in the surrounding country till the rebel horde had left. A few secessionists, who remained and pointed out to the Southern rabble the houses of prominent Union men, it is to be hoped will be dealt with as they deserve. It would be a good idea to confiscate their goods for the benefit of the sufferers.

Throughout the war Waud's writings suggest strong pro-Union sentiments. He used such words as "horde," "rabble," and "devilish grey coats" to describe the Confederates. Three months after Antietam he would witness the Federal looting of Southern homes in Fredericksburg; there is no record that he was similarly outraged when the depredation was practiced by men in blue uniforms.

Removed from command of the Army of the Potomac and replaced by General Ambrose E. Burnside after Antietam, the popular McClellan held a final review of the army at Warrenton, Virginia, in November 1862. Waud had occasion to recall the events following that last review during General Winfield Scott Hancock's campaign for President on the Democratic ticket in 1880. At a meeting at Governor's Island, New York, Hancock produced a letter of support from a regular army officer who was present in Warrenton when McClellan was removed as commander. The officer, along with a number of general officers and colonels in Hancock's command, had called on Hancock at that time to express their indignation. Hancock, the letter recalled, stopped them by saying, "Gentlemen, we are serving no one man; we are serving our country!"

Waud, then residing at 162 East 122nd Street, New York, had come to Governor's Island to draw some sketches to illustrate a life of General Hancock, and he unexpectedly volunteered corroboration of the contents of the letter. He then continued with his own story of the events at Warrenton:

XIII. Lieutenants Custer, Jones, and Bowen photographed in May 1862, near Yorktown, by James Gibson. Custer and Bowen appear here much as they looked at the time of McClellan's dismissal. Note that Custer is gripping a revolver by the barrel and Bowen is seated upon one of the cumbersome cameras of the period. (Collection of the Library of Congress)

Yes, sir; I have not the slightest doubt that that is true. Not only did General Hancock frown down upon any such project as that, but it received General McClellan's severest condemnation at the same time. Not that any such project as retaining McClellan in command by force after he was removed was contemplated by anybody seriously. Whatever was said came from the mouths of young, rattlebrain officers under the excitement of liquor. I know something about this thing personally. I was present at the last review and rode down the line with the officers of the staff. Everybody who saw the scene will remember that it was one of great excitement.

XIV. Waud's original sketch of Fredericksburg from Falmouth. (Collection of the Library of Congress)

The soldiers exhibited great grief, and there were shouts from thousands of throats: "McClellan, come back! come back!" After the review some of the officers of the staff and others were invited to headquarters—until recently the headquarters of the beloved Little Mac, but henceforth for a while to be those of Burnside. I was an acquaintance of many of the officers, and was invited to go with them. Some of the younger ones had already shown their feeling in a manner not altogether creditable. Riding with the staff down the line was the correspondent of the *Tribune*, Richardson, who was afterward shot by McFarland. Richardson regarded the enthusiasm of the soldiers with sneers, and that, together with the abuse to which McClellan had been subjected by the paper he represented, was too much for some of the young fellows. Custer and Nick Bowen [13] and two or three others went for him, and although Richardson was finely mounted he could not ride very well, and these fellows succeeded in running him into a ditch. Coming flushed from the accomplishment of this very questionable operation these young officers presented themselves at McClellan's headquarters, in accordance with invitation, to take a parting drink. . . . You know that occasionally, if not oftener, the officers, great and small, did take a drink. These young fellows may have had, and probably had had already, a drink more than was good for them. As they crowded into headquarters there was more or less talk by them. Some of them, just who I cannot say, but some of the younger ones, Custer or Nick Bowen, or some of them, spoke out so as to be heard, to the effect that Little Mac ought to take the army to Washington and settle that place, and then go for the rebels afterward.

McClellan heard the remark. I shall never forget the severe, though dignified, manner in which he replied to it.

"Gentlemen," he said, "I suppose that remark was intended for me to hear. You

[13] Lieutenants George A. Custer and Nicolas Bowen.

almost insult me by allowing me to hear it. Gentlemen, please remember that we are here to serve the interests of no one man. We are here to serve our country."

The sinning officers made no reply, and shortly afterward the gathering broke up.[14]

During late December 1862 and early January 1863, Waud is mentioned in the diary of photographer David B. Woodbury as being with the army in the area of Falmouth and Aquia Creek, where the artist bought a double-barreled shotgun from Woodbury for ten dollars. At this time Waud's sketches appeared in profusion throughout the pages of *Harper's*. In the December 13 issue he described his first sight of Fredericksburg:

> From Falmouth we got the first view of Fredericksburg, which I presume has been often described before. It is a deserted-looking place; the church clock, however, sounds the hour regularly—a *strange, familiar* sound. The rebel pickets line one bank of the river, ours the other. In the streets of the city they can be seen lounging about, although they do not seem to have that curiosity about us which we manifest toward them. On one of the houses an English flag (the cross of St. George) is flying, and in the country beyond the smoke of the camps shows that a large force is there. (Illustration XIV.)

[14] See Appendix, page 186, for Waud's detailed appraisal of McClellan and other commanders of the Army of the Potomac.

XV. A news vender in the vicinity of Culpeper, Virginia, November 1863. The man second from the left, though unidentified, strongly resembles Alfred Waud; note the similarity in profile and hat as compared with the photograph of Waud in Illustration XXI and the self-portrait included in Plate 28. (Collection of the Library of Congress)

Crossing the Rappahannock (Plates 40 and 41) on December 11, Burnside occupied Fredericksburg and two days later hurled his army against the Confederate positions west of the city. Waud's sketch of the charge of Humphrey's division against Lee's entrenched lines on Marye's Heights, a "magnificent defensible position, strong as Sebastopol," was appended with a long and impassioned word description of the futile attack (Plates 43 and 44). Burnside compounded his disaster at Fredericksburg by ordering a flanking movement up the Rappahannock by his army which became hopelessly bogged down in the infamous "Mud March" (Plate 47).

Discredited, Burnside was replaced by General Joseph Hooker as commander of the Army of the Potomac, but Hooker's bright hopes for crushing Lee's army were dashed at the Battle of Chancellorsville, May 2 and 3, 1863, and once more the Union army was in retreat. At Chancellorsville Waud's pencil would again record the flight of the Eleventh Corps (Plates 52 and 53).

Flushed with its successes over the Federal armies at Fredericksburg and Chancellorsville, the Confederacy moved again to the offensive, and in the summer of 1863 long columns of gray-clad troops were on the march north into Pennsylvania.

New York *Herald* correspondent Lynde Walter Buckingham, of a prominent Boston family, had formed a close friendship with Alf Waud. On June 22, 1863, Buckingham was on his way to Washington with his reports of recent cavalry engagements when, near Aldie, Virginia, he was ambushed by a party of Mosby's guerrillas. His horse bolted at the first shots, raced down a steep hill, stumbled, and threw Buckingham to the ground, where Union pickets found him. He was taken to a "little brick church" being used as a hospital, where he died of a fractured skull. The *Herald* reported that Waud, "hearing of the affair repaired to the place, and himself dug the grave for the burial of his old friend in a little graveyard adjoining the church, where the remains were interred." Taking charge of Buckingham's personal effects, the bereaved Waud rejoined the Army of the Potomac, then moving north on a collision course with Lee's invading hosts.

Just when Waud arrived on the field of Gettysburg is a matter of conjecture, though it would seem that he came up with the main body of General George G. Meade's army during the night of July 1–2, 1863. His first drawings of Gettysburg to appear in *Harper's* show Hazlett's battery on Little Round Top during the second day's battle and, although he sketched two versions of the death of General Reynolds, which occurred on July 1, it is unlikely that he saw this incident, but rather worked from later eyewitness accounts. His sketch of Stevens' battery in action near Cemetery Hill (Plate 57) and the charge of the Louisiana Tigers (Plates 58 and 59) place him on Meade's right wing late on July 2. He was also apparently close enough to the fighting around Devil's Den to represent in *Battles and Leaders of the Civil War,* twenty years later, a version of that struggle "from a war-time sketch." At Gettysburg Waud certainly produced the best drawings of that three-day bloodbath. Edwin Forbes of *Leslie's,* the only other "Special" on the field, admittedly lost his nerve in the rain of shot and shell preceding and during Pickett's climactic charge on July 3,

and remained behind the cover of Cemetery Ridge while the battle raged out of sight. Waud was most probably an eyewitness to Pickett's assault; his drawing of the event could well be the only version made by an actual observer on the field. The drawing itself is 13 5/8" x 20 3/4" and is rendered in pencil and Chinese white on brown paper. In the background are meticulously represented the ranks of attacking Confederates, their hedges of bayonets accented, like the smoke of battle, with Chinese white. Examination of the original sketch indicates that Waud spent a good deal of time and care on it; it is highly detailed and in his best style. *Harper's* engravers faithfully copied the original drawing which appeared as a double-page spread on August 8, more than a month following the battle (Plate 60).

The most famous wartime photograph of Waud, taken at Gettysburg, shows him seated on a rock at Devil's Den, where Confederate sharpshooters had proved so effective against Federal gunners on Little Round Top (frontispiece.) Sketchbook in hand, with revolver, wearing jackboots, thirty-four years old and the very picture of a nineteenth-century cavalier, he posed for the stereoscopic camera of Alexander Gardner. Waud's print of this picture is inscribed on the reverse in his own hand:

> In the Devils Den
> A. R. Waud. The only
> portrait taken on the field
> of Gettysburg. 4th of July 1863—
> Alex Gardner Photo.

After Gettysburg Waud followed Meade's halfhearted pursuit of Lee's retreating army to the Potomac, producing a double page of sketches entitled "The Maryland Campaign." Engraved in *Harper's*, August 15, the montage included views of Williamsport, the site of Lee's crossing, rebel prisoners, and a charge of Custer's 6th Michigan Cavalry near Falling Waters. During the winter of 1863 Lee and Meade maneuvered for position in Northern Virginia, and Alf Waud was on the march again, his sketchbook filled with the highlights of the campaign, the now almost forgotten engagements at Rappahannock Bridge and Kelly's Ford (Plate 64). Meade's advance carried him as far as Mine Run, Virginia, where Lee's position proved too strong to risk a major battle, and the weary and footsore Army of the Potomac withdrew to the Rapidan, having accomplished little. By February 1864 the principal enemy of the army had again become the Virginia mud (Plate 66).

In late February and early March 1864 Waud was the only civilian to accompany a a cavalry raid across the Rapidan by General George A. Custer's command. The Union troopers requisitioned horses, burned Confederate supplies (Plate 67) and returned to their own lines without the loss of a man. A double page of Waud's drawings, "Scenes Connected with General Custer's Late Movement Across the Rapidan," appeared in *Harper's* March 26 and was accompanied by the artist's own spirited account of the raid:

Leaving Madison Court House, a handsome town at the foot of the Blue Ridge,

soon after midnight, CUSTER'S command rapidly pushed on in the still night through a country alternately open and woodland toward the Rapidan. All went quietly until we reached Wolftown, where the Sixth Pennsylvania Cavalry, being in the advance, was fired upon by a rebel force; but drawing their sabres they dashed on, putting the enemy to flight without loss, and the head of the column soon reached the Rapidan. Having captured a wagon loaded with hams and two negroes, the command forded the river without opposition and pushed on, seizing all the horses on their way and all the male citizens—as a precaution against bushwhacking and to prevent information being given to the enemy.

As we proceeded we found a tolerably well-cultivated and high rail-fenced country, the farmers plowing in the fields; when the horses were worth it they were taken in the name of the United States; and occasionally some of the men would make a descent upon the poultry while their officers were not looking. In one place a very handsome lady, quite young, expostulated loudly with a cavalryman for taking the farm-horses. "My dear Miss," said the soldier, "we do not want to take your horses;

XVI. Alfred Waud is seated at the left in this photograph of officers of the Artillery Brigade, 3rd Corps, Army of the Potomac. Left to right: Waud, Captain O'Neil W. Robinson, Captain J. Henry Sleeper (10th Massachusetts Battery), and Captain Samuel A. McClellan. The photograph was made at Brandy Station, Virginia, in December 1863, by James Gardner. See Plate 64 for Waud's sketch of Sleeper's battery at Kelly's Ford. (Collection of the Library of Congress)

XVII. Waud standing at the right with the same group of officers shown opposite. (Collection of the Library of Congress)

ours are much better; and besides it goes against our feelings, but military necessity requires this step, and we are merely the agents of unrelenting destiny." In spite of her concern the pretty creature laughed at such eloquence from a rough cavalryman.

At a turn of the road we met a couple of children on a horse; that horse the men did not take; they looked too innocent to be molested. In the town of Stannardsville the people came out to see the procession, as if it were a show got up for their amusement. The men were exceedingly disgusted when they found they had to accompany the column as temporary prisoners. The female relatives of one person hung about him with outcries and shrieks, as if they imagined he would be led at once to execution. In the afternoon we reached and crossed the Rivanna River, and found the enemy in force near Charlottesville. A squadron of the Fifth regulars, under Captain ASH, scouting on our left, came so suddenly upon an artillery camp that the gunners had barely time to run off the guns by hand. Before they had recovered their surprise the camp was in flames, the caissons blown up, harness, forges, and battery-wagons destroyed, and our handful of dare-devils off again. At this time train after train came up from Gordonsville with troops, and the General recalled his column, which was at this time being shelled in a random way by the enemy's artillery, answered by our two little guns, which checked an effort to turn our left. Recrossing the river, the pioneers soon put the bridge in flames, and destroyed a large mill full of Government corn and meal [Plate 67], the enemy's infantry keeping up a wicked but harmless skirmish-fire the while. Returning, the troops were

halted about four miles from the river to feed and rest. The night was rainy, and all had to lie upon the ground and get wet through. It was difficult to get fires to burn, and the rain began to freeze upon the limbs of the trees, so that by morning every thing appeared to be cased in crystal; and when the enemy's forces got in our way, to contest the return of the troops, the cannon-shot made a wonderful crashing among the frost-bound limbs of the forest. After two or three pretty little skirmishes, in which our troops invariably had the advantage, General CUSTER inveigled them down a wrong road, and then, having started them upon a false scent, quietly recrossed the Rapidan, without the loss of a man, and with but few wounded, bringing with him a large number of horses and refugees—colored people

XVIII. This enlarged portion of a photograph of Company I, 6th Pennsylvania Cavalry (Rush's Lancers) was made at Falmouth, Virginia, in June 1863. The following winter Waud accompanied these troopers on Custer's raid across the Rapidan. The officers (wearing shoulder straps) are identified as Captain J. Starr and Lieutenant F. Furness; the civilian seated at the far left, though unidentified, is obviously Alfred Waud. At Gettysburg, a few weeks after this photograph was made, the artist appears in basically the same attire (frontispiece). A photographer's wagon is parked in the background. (Collection of the Library of Congress)

XIX. Waud's friend, Major General Gouverneur K. Warren. (National Archives)

—and some thirty prisoners, soldiers; the civilians being all allowed to return to their homes when it was no longer possible for them to do us damage. Like lost children the command was welcomed back into the lines by the forces of General SEDGWICK, who was not without anxiety that we should be all used up when he heard the distant guns in the morning.

In March 1864 General Ulysses S. Grant, with an unblemished record of Union victories in the west, came east to take command of all Federal armies. Two months later Alf Waud was with the Army of the Potomac when it crossed the Rapidan and struck at Lee's army in the Wilderness. His sketches depicted Wadsworth's division in action in the tangle of the Wilderness (Plate 69) and the dramatic scene of wounded Federal soldiers being carried from the burning woods (Plate 70). At Spotsylvania Waud inscribed his sketch of the bloody struggle for the rain-swept salient on May 12 as "The toughest fight yet" (Plate 71). Of another sketch showing General Barlow's troops in front of Confederate works at Spotsylvania, he wrote in *Harper's:*

> The sketch was taken from the Sheldon House, a mansion nearly two hundred years old, built of imported glazed brick, and occupied by a lot of women and children, who refused to leave, although fifty or sixty rebel cannon-shot passed through the building. They sought refuge in the cellar. . . .

While at Spotsylvania Waud also portrayed his friend, General Gouverneur K. Warren, mounted on a white horse and bearing a tattered flag, rallying the Marylanders (Plate 72). During his sketching "excursions" in camp and battlefield, Waud had developed a special friendship with General Warren; in *Battles and Leaders of*

XX. Entitled "Christmas 1864," this photograph was made by Alexander Gardner in Washington and shows Waud second from the right. To Waud's right is Captain F. Colburn Adams. Seated second, third, and fourth from the left of the picture are J. Knox of the Boston *Herald*, and Simon P. Hanscom and Frank G. Chapman, both of the New York *Herald*. After the war (1868) Waud illustrated Captain Adams' book, *Siege of Washington, D.C. Written Expressly for Little People*. (Malcolm F. J. Burns Collection)

the Civil War there is an engraving from a Waud drawing showing Warren surveying the field of Gettysburg from the summit of Little Round Top (Plates 55 and 56). In September 1863 Waud received the following invitation, no doubt for the purpose of sketching the event, from General Warren to attend a presentation of a sword to the general:

> Sir:
> Having been honored with the gift of a sword by the citizens of my native place, I would be pleased to see you at the presentation at 2 oclock P.M. on Wednesday the 30th. You must be sure to come if nobody else should.

There is no record that a sketch of the presentation was ever made; at least it was never published in *Harper's* as Warren had probably hoped. Waud's friendship with Warren seems incongruous; Warren, given to outbursts of temper and profanity, was disliked by a number of general officers, despised by others, and was eventually relieved of his command by Sheridan at Five Forks in April 1865. Waud, on the other hand, enjoyed a reputation during the war that would seem to be the complete opposite. It is one of those vagaries of history for which there has been no explana-

48

tion forthcoming. Fifteen years after the war Warren called upon Waud for his testimony in clearing up the facts surrounding the former's supersession at Five Forks.[15] However, Waud's testimony was apparently never needed. Exonerated by a court of inquiry of culpability in November 1882, Warren never lived to see his name cleared. He died, an embittered man, in August of that year.

Waud was obviously well thought of by many officers in the army, an observation noted by George Augustus Sala (page 11). Meade had favored him as the only newspaper correspondent to accompany the army's advance at Raccoon Ford (page 29). In a letter to his brother,[16] dated October 3, 1864, William Waud wrote: "By the Bye Old Patrick[17] complimented you very highly for never having conveyed information injurious to the cause during the whole time you were in the army." And General Oliver O. Howard recommended Alfred Waud after the war to agents of the Freedman's Bureau as a "genial, educated gentleman."

[15] See Appendix, page 187, for Warren's letters to Waud.
[16] In the same letter William asked his brother for the loan of drawing paper, "my sketch book Blankety clothes etc. having been gobbled at Reams Station fight." (A Confederate victory on August 25, 1864.)
[17] General Marsina Patrick, Provost Marshal General.

XXI. "A Happy New Year 1865" is the title of this photograph taken in Washington by Alexander Gardner. Waud is seated third from the left in this distinguished group gathered around the punch bowl. Both photographs are reproduced here for the first time. (Malcolm F. J. Burns Collection)

At Cold Harbor on June 3, 1864, Waud was an observer of the costly Union assault upon Lee's entrenched lines (Plate 73). But with Grant now in over-all command there would be no more retreats by the Army of the Potomac in spite of soaring casualties numbering 55,000 men in one month of almost continuous fighting. "I propose to fight it out on this line," Grant had wired Halleck in Washington, "if it takes all summer." Waud was himself appalled at the "fearful sacrifice" of lives." [18]

After Cold Harbor Grant moved the army southeast, secretly crossed the James River, and struck suddenly at General Beauregard's defenses around Petersburg. The battles for Petersburg and ensuing siege of that city kept Alf Waud and his brother Will, now also in the employ of *Harper's*, busy sketching the events and terrain (Plates 74 through 84). Following the Union debacle at the Battle of the Crater (Plates 83 and 84), the Army of the Potomac settled into an unaccustomed routine of trench warfare, and by autumn Alf Waud was off to picture Generals Sheridan and Custer in their sweep up the Shenandoah Valley (Plates 86 through 90) and was on the field sketching the Battle of Winchester of September 19, 1864.

In November 1864 Waud was again, after three years, at Fortress Monroe. A War Department pass, issued on November 25, 1864, reads: "Pass Alfred Ward [19] and James Gardner,[20] Photographers, to Fortress Monroe Va—Pass expires Nov 28, 1864." Waud was still at Fortress Monroe on December 13, where he sketched the departure, in heavy seas, of Admiral Porter's powerful fleet of warships and transports on its way to reduce Fort Fisher in North Carolina (Plate 94). A few days later he was at City Point, Virginia, in the company of Thomas Nast. A pass dated December 20, 1864, issued by the Provost Marshal General, Army of the Potomac, reads: "Pass the bearer Thos. Nast—A. R. Ward from these Head-Quarters to City Point for the purpose of——Pass will expire December 25, 1864." Waud apparently spent little time at City Point for he was off to Washington for Christmas and New Year's, where he was photographed by Alexander Gardner toasting the holidays with colleagues gathered around a punch bowl (Illustrations XX and XXI).

Waud's sketches diminish in number through 1865; in February a drawing of "Lady Clerks Leaving the Treasury Department at Washington" appeared in *Harper's*, and in March three fine drawings of Harpers Ferry were published as a double-page spread (March 11, 1865).

Waud was back on the Petersburg front for the final chapters of the war, sketching Sheridan's victory at Five Forks on April 1, 1865 (Plate 96) and accompanying the Union army into Petersburg when that city finally fell on April 3 (Plate 98). In Petersburg he pictured, in careful detail, the charred ruins of General Lee's headquarters, a stark symbol of defeat (Plate 99). Following in the wake of Lee's retreat, he was witness to the surrender of Ewell's Corps at Sayler's Creek on April 6 (Plate 100).

[18] See Appendix, page 186, for Waud's assessment of battle losses.
[19] Waud's name was frequently misspelled on War Department passes.
[20] James Gardner, son of photographer Alexander Gardner.

This drawing of the disintegration of the Army of Northern Virginia was, no doubt, delivered to *Harper's* but was never published; *Harper's* coverage of Lincoln's assassination and funeral pre-empted from its pages the pictures of the final death throes of Lee's army in Virginia. Waud redrew the scene at Sayler's Creek for *Battles and Leaders* in the 1880s, in which, curiously, he substituted an army forge for the caisson shown in his original pencil sketch made on the spot (Plate 101).

No correspondent was present inside the McLean house at Lee's surrender at Appomattox on April 9, 1865, but outside Waud recorded the moment of Lee's departure from the surrender scene (Plate 103). Shortly after the surrender he made a hurried sketch of Federal soldiers chopping up an apple tree about a mile from Appomattox Court House where Lee had waited for Grant's word on a meeting. The wood was cut into souvenirs, and within an hour the tree and its roots had disappeared! Waud also depicted Union soldiers sharing their rations with Lee's starving Confederates after the surrender; the picture appeared as a pen sketch in *Battles and Leaders* and bore the notation, "from a sketch made at the time."

Waud was in Richmond after Appomattox long enough to sketch firemen pushing down the remains of burned dwellings on Capitol Square, the ruins of the Gallego flour mill, and a view of Libby Prison (Plate 106). However, the pictures showing the devastation in the Confederate capital which appeared in *Harper's* for April 22, 1865, were all credited to artist A. W. Warren.

Waud returned to Washington shortly after Lincoln's assassination, where he made a sketch from the dress circle of Ford's Theater, showing the appearance of the stage and the President's box. The drawing was apparently a guide for the engravers at *Harper's*; on it he noted "spot on which the man [Booth] jumped," indicated the colors of some of the furnishings, and instructed the engraver to "correct the Perspective" (Plate 107).

Now the Homeric conflict was over. The guns had fallen silent. For Alf Waud and his artist colleagues there would no longer be any "risk from damned shells and bullets." For these sketch-pad soldiers peace must have seemed an anticlimax, and one cannot help but conjecture whether, in the ensuing years, they may not have contemplated the excitement of those war years with a certain pang of nostalgia.

On June 3, 1865, *Harper's* paid the following tribute to "our artists during the war":

> We may be pardoned for special pride in our own artists who have gone through all the long and stirring campaigns of this war, commemorating its most interesting incidents and noted men, so that the volumes of the "Weekly" are really a vivid history of the struggle. Messrs A. R. Waud, Theodore R. Davis, William Waud, Robert Weir, Andrew M'Callum, A. W. Warren and others have been no less busy and scarcely less imperilled than the soldiers. They have made the weary marches and dangerous voyages. They have shared the soldiers' fare; they have ridden and waded, and climbed and floundered, always trusting in lead pencils and keeping their

paper dry. When the battle began they were there. They drew the enemy's fire as well as our own. The fierce shock, the heaving tumult, the smoky sway of battle from side to side, the line, the assault, the victory—they were a part of all and their faithful fingers, depicting the scenes, have made us a part also.

Alf Waud, so far as is known, executed few paintings in color. He remained essentially a sketch artist after the war, providing the picture for the engravers' tools. His wartime colleague during the Yorktown campaign, Winslow Homer, went on to become one of America's greatest painters; *Leslie's* Edwin Forbes spent the remainder of his life working up his war sketches and produced a series of copperplate etchings ("Life Studies of the Great Army") which won for him an award at the Centennial Exposition in Philadelphia in 1876. Waud's pictures, with their quick, light touch, are those of the artist–reporter, reflecting the action and spontaneity of the moment. Within the framework of the historian–reporter lies the real value of his work; certainly his battle pictures were the best of all his contemporaries'. Something about a Waud sketch seems to say, "This is how it was"—a horizon obscured by smoke from rebel batteries, Union guns flashing in the near foreground, the regimental flags of an attacking column of troops sweeping by as shells burst overhead. And he was a first-rate journalist in word as well as picture; more often than not he "subjoined" his drawings with vivid descriptions and detailed notations. These word descriptions appear throughout the war issues of the *New York Illustrated News* (1861) and *Harper's Weekly* (1862–1865). Waud surpassed all other field artists in the output of published drawings of the war—129 appeared in the *News,* and 215 in *Harper's,* for a grand total of 344. Arthur Lumley was his nearest competitor with 298 published sketches. Without depreciating in the least the work of other competent field artists of the Civil War, we feel secure in rating Alfred R. Waud a giant among his contemporaries.

AFTERWARD

While this book is primarily concerned with Alfred Waud's Civil War drawings and experiences, we would be remiss in not lingering for a while upon his postwar career during which he chronicled so much of the history of the America of the mid-1860s and the 1870s in words and pictures. It was, in fact, a period that encompassed the greater part of his professional life.

In its April 28, 1866, issue, *Harper's* announced that it proposed to publish a series of illustrations presenting the characteristic aspects of life in the Southern States, then experiencing the agonies of Reconstruction.

> We have for this purpose a corps of special artists in those States, who have had years of experience in the special class of duties which they have undertaken, and who understand the peculiarities both of the region and of the people. During the war these artists have followed our armies, and have furnished the public through the pages of this paper with illustrations of the great conflict so graphic and faithful that they will be appreciated as long as our history shall be read. . . .
>
> It is like the rising of a new world from chaos. To us the late Slave States seem now almost like a newly-discovered country. For the first time we ask earnestly: What are their resources and opportunities? How has the great earthquake left them—with what marks of ruin upon their cities and fields—with what changes of social and political character? We shall leave to our artists the task of answering these absorbing questions, so far as it is possible to answer them by means of pictorial representations.

The artists dispatched to the South and West were two of *Harper's* best—Alfred R. Waud and Theodore R. Davis. The latter went south through the Southern coastal states, then turned west; Waud would journey westward via Cincinnati, Louisville, and Nashville, his nimble pencil recording everything of interest as he went, to his drawings appended his own astute comments and personal observations. From Cairo, Illinois, he went on to Memphis by the steamer *Ruth*, which he described as "one of the finest river boats," and then to Little Rock, Arkansas, where he sketched the mustered-out black soldiers (Plate 108). In Louisiana he depicted life among the Acadians, and he quite possibly ventured into eastern Texas as suggested by his drawing "A Drove of Texas Cattle Crossing a Stream," which was published in *Harper's* on October 19, 1867, the year following his trip.

Waud was already in Cincinnati in March 1866, at which time he recorded a fire in Pike's Opera House that occurred on the twenty-ninth of that month. (Eng. *Harper's*, April 14, 1866). Writing from Cincinnati, Waud quipped, "Having heard much about the superior beauty of Western ladies, I had gone about Cincinnati with an artist's eye for the study of that interesting subject" (*Harper's*, May 12, 1866). In the same isue (April 28) in which *Harper's* announced the dispatching of artists to the South, Waud is represented in a self-portrait entitled "Our 'Special,' A. R. W., on His Journeyings" (Illustration XXII). The cut shows him slogging through the rain on horseback, and in the accompanying article, dispatched from Cairo, he says in part:

> Passing along the levee at Cairo, with its dust, filth, and obtrusive drinking-saloons, gaping wide open for victims to the trash within, it would appear to a stranger, from the great number of such places, that the people of Cairo had powers not accorded elsewhere to ordinary mortals of resisting the effects of "tangle-leg," "red-eye," "twist-knee," and other brands peculiar to the locality. Outside of each place gathered a knot of hard-looking fellows. There is a suspicious air of "lying-in-wait" common to these frequenters of the levee which is not calculated to inspire confidence in a stranger....

And from Louisville, he commented:

> A stranger from the East naturally wonders at the extensive interest which whisky holds in the countries bordering on the Ohio. Here the people that distill the liquor are not at all ashamed of their business. The denizens of the more Eastern States have a sneaking consciousness that the distilling business is not compatible with respectability, and evince a cowardly spirit in fabricating excuses for their indulgence in the fiery juice. Now in the West a man takes his whisky "like a man" without reference to his doctor, a stomach-ache, or a cold. As churches are the prominent institutions in an Eastern town, so here the still-house overshadows all its neighbors and proudly takes the first rank.... (*Harper's*, May 5, 1866)

Louisville, with its *air pollution*, was a disappointment to the artist:

> Thus Louisville—of which I had formed a charming ideal as a place where pretty houses nestled among the trees out of the reach of the scorching rays of the sun, and where the fiery nature of the Southron slumbered in a luxuriant sensuousness—turns out to be in fact only a rival of Pittsburg. Masses of smoke, belched from numberless chimneys, keep the place in a perpetual fog, and, descending in showers of soot, produce a monotone of color not cheering to the sight.

In Nashville Waud noted that the "mistletoe abounding upon the trees would make an Englishman feel 'quite at 'ome.' " Memphis, he wrote, "has now the unenviable reputation of being the worst behaved city in the Union. There is a floating population here, made up of the dregs of both armies, which would be a curse to any city."

Waud provided the following observation for a scene sketched in front of the Washington Hotel in Vicksburg, engraved in *Harper's*, June 30, 1866:

> The scene in front of the Washington Hotel is characteristic. As you go South you notice the gradual disappearance of reading and writing rooms, and of decent sit-

ting-rooms for the guests. Thus the sidewalk becomes the only available place for loungers. Being more limited than in larger cities, when, in Vicksburg, the pavement is covered with chairs, there is not much space for passengers, especially ladies, to get by. They do not seem to mind it though, but thread their way through the *gentlemen* and the tobacco-juice with commendable fortitude. It is not agreeable to ladies in New York to have to pass the groups of loungers at the hotels. What would they do if the aforesaid loungers brought chairs out and spread themselves all over the sidewalk, smoking, spitting, wrangling, and so forth?

On July 14 *Harper's* published a double page of Waud's beautifully detailed panoramic pictures of Vicksburg and Natchez. A lengthy text by the artist accompanied this spread, in which Waud noted:

> Vicksburg is governed about as badly as Memphis. The city government, like that of Memphis, is in the hands of foreigners, the police being among the worst specimens. . . . Your artist was severely taken to task by the ladies for holding up the Southern ladies to ridicule in pictures.[21]

In the same issue Waud sketched a duel in New Orleans to which he "hurried out at four o'clock in the morning." One antagonist went down with a bullet in the leg; his opponent collapsed from "the effect of his horror at, as he supposed, having killed his man—"

Commenting on a drawing in the June 23 number of *Harper's*, depicting a May festival of children in New Orleans, the artist observed:

> The . . . children are much older, so to speak, than the children of the North. Those who have reached the mature age of twelve have left childhood entirely behind them, and are prepared to—and do—act the part of men and women.
>
> Going to school at a very early age, the climate, like a hot-house, forces them quickly to maturity.

And describing a "Sunday in New Orleans," Waud wrote:

> Opposite the French Market is the Cathedral; an effort to hear the services there ended in failure, owing to the noise of a neighboring billiard saloon, and a canvas-covered show, with a big drum, to which was added the constant rattle of carriages.

Repairing to a cockfight near General Beauregard's home, he sketched a cosmopolitan Sunday audience where "full-blooded negroes and elegant mulattoes sat side by side with whites, and among the latter were Yankee merchants, Southern planters, professional gamblers, Mexicans, Cubans, Frenchmen, and Spaniards" (*Harper's*, July 21, 1866).

Of New Iberia, Louisiana, Waud noted in *Harper's*, August 11: "This is a point at which a good portion of the cattle herds driven from Texas arrive. The herders and drovers—rough-looking fellows—are often seen riding about the streets." (The term "cowboy" had not yet come into common usage.)

[21] This was probably in reference to Waud's drawing in *Harper's*, June 3, 1865, showing several ladies of Richmond going to receive government rations. "Don't you think that Yankee must feel like shrinking into his boots before such high-toned Southern ladies as we," the lady in the drawing is quoted as saying as she snubs a passing Union officer on the street (Illustration XXIII).

XXII. Alfred Waud's self-portrait, "Our 'Special,' A.R.W., on his journeyings," which appeared as one of the first in a series of sketches made by the artist while on assignment for *Harper's* in the West and South in 1866.

OUR "SPECIAL," A. R. W., ON HIS JOURNEYINGS.

The artist was in Charleston, South Carolina, in June, where, on the twenty-fourth of that month, he witnessed and illustrated a street fight between whites and blacks. He was impartial in placing the blame:

> Now in Charleston and its vicinity there are some very bad characters among the blacks. A number of these turbulent fellows were in the crowd, but it is equally true that the whites were quite as bad, and very desirous of battle with the "inferior race."

Waud's pictures in *Harper's* in September emanated from Baton Rouge and Mobile and included two sketches of Jefferson Davis's plantation. He found in Baton Rouge, "like all the Southern cities, business . . . entirely stagnant, the principal occupation being to keep out of the sun and drink iced drinks."

He was back in New York again by October, as evidenced by a sketch made in Brooklyn during the latter part of that month. Featured on the first page of *Harper's* of November 10, 1866, was Waud's drawing, "Arkansas Travelers," made early on the trip west. It depicted a motley party of armed horsemen and was appended by the following remarks:

> Being desirous of making a perfectly truthful representation, I have refrained from adding a fiddle to the outfit of either of these gentlemen, although, out of respect to the time-honored custom of Arkansas travelers, the temptation was great. The little group is sketched just as it appeared. They are calculating the chances of crossing a bayou and cedar swamp. On what enterprise they were bound deponent hath no knowledge; and being rough-looking fellows, armed with the long rifle, no intimate acquaintance seemed desirable. It is not fair, however, to judge from appearances, and they were probably good citizens enough as times go; certainly the presence of the bundles of corn-fodder which some of them carried gave no evidence of their intention "to live off the country." If they were bound on a hunting excursion they have the artist's best wishes, out of a powerful fellow-feeling for the sport.

Along with thousands of words of commentary, eighty-five of the drawings Waud produced during the Southern trip were engraved in *Harper's* during 1866–1867 and included three double-page spreads. His fellow artist, Theodore R. Davis, writing in 1868, called them "the most interesting sketches ever published by that journal."

The 1869 edition of A. D. Richardson's book *Beyond the Mississippi,* published in Hartford, Connecticut, contained forty of Alfred Waud's illustrations; other contributors were his brother, William, Edwin Forbes, F. H. Schell, J. R. Chapin, and Thomas Nast—all former Civil War field artists.

Henry M. Alden, editor of *Harper's New Monthly Magazine,* in an article appearing in that publication in May 1900, mentions both Waud brothers working on wood blocks at *Harper's* offices. This was probably at a period following the war, during which time (1865–1867) Alfred Waud's name appears on engravings published in that magazine. In the following excerpt from Alden's article, he recalled *Harper's* art department:

> The Harper establishment has been from the beginning a great workshop. The atmosphere of the place did not suggest any special aesthetic refinement. There was

XXIII. Waud's drawing in *Harper's Weekly,* June 3, 1865, was probably the reason for the ladies of Vicksburg taking the artist "to task" during his visit to that city in 1866.

a corps of engravers who worked on a salary, meeting all requirements for the illustration of the books and periodicals of the house. Often in the engravings of the *Weekly*, and sometimes in those for the Magazine, different engravers would work on different portions of the same block. But the utmost possible attention was given to securing the most excellent workmanship. Mr. Henry Sears, who was at the head of this department, was a faithful and efficient superintendent, and, in spite of the defects of such a system, there were instances of eminent individual mastery of the art—more and more of them as the individual eminence of the artists who made the drawings led to the exaction of better engraving. And these artists had their workshop as well, in a room of their own, under the superintendence of Charles Parsons, who had early in 1863 succeeded John Chapin. One of my most vivid early recollections of the establishment is of this room, with a dozen or more artists seated at desks, drawing on wood, and at times varying their work with riotous hilarity. There were Harry Stephens, W. S. Jewett, Sol Eytinge, William and A. R. Waud, Theodore R. Davis, Granville Perkins, Tom Nast, C. G. Bush, and a number of others whose names have escaped my memory. These artists had no models, but they did remarkable work, and several of them were excellent painters, whose work was accepted for Academy exhibitions. Mr. Parsons was an eminent water-color painter. Some of these artists followed our armies in the field and contributed to *Harper's Weekly* sketches of battle scenes that were memorable for their accuracy and graphic delineation.

Waud's versatility as an illustrator is exemplified in such varied subjects as the steamship *Santiago de Cuba* stranded on Absecon Beach near Atlantic City, showing the landing of passengers in a heavy surf, and in the same issue (June 8, 1867) a sketch of new regulation uniforms of the U. S. Artillery in Richmond, Virginia. An elaborate two-page cut portraying the docks of New York, published September 4, 1869, takes on additional importance today as an historical document, detailing a vast array of ships and vehicles of the period (Illustration XXV).

In March 1869 Waud was in Washington for the inauguration of President Grant. From the Senate gallery he sketched Schuyler Colfax taking the oath of office as Vice-President; the drawing appeared on the first page of *Harper's* for March 20, 1869. Waud designed the invitation to the inauguration reception and dance held at the United States Treasury building on the evening of March 4 and was himself a guest at that reception (Illustration XXVI). The ball was not an overwhelming success; the New York *Tribune* reported that "nobody seemed to know what to do or where to go. As to dancing, it was as great a failure as the Barmecide's supper." And *The New York Times* made this curious observation: "A. R. Waud put in an appearance as a half-way apology for the execution of the tickets of admission which he designed." Among the last of Waud's work to appear in *Harper's* while the artist was in the regular employ of that establishment were such diverse subjects as a hurdle race at Monmouth Park in August 1870, and a bear hunt in the Southern canebrake, published in October of the same year.

In 1871 Waud was again in Louisiana, accompanied by writer Ralph Keeler, reporting life in New Orleans and the Mississippi delta for the newly formed publication *Every Saturday*, a short-lived illustrated journal. The sketches made by Waud in

XXIV. *Harper's* building on Franklin Square, New York City, during the Civil War. (*Harper's New Monthly Magazine*, December 1865)

New Orleans are among his best works; originally in the possession of Mr. Malcolm F. J. Burns, these drawings, 470 in number, are now owned by The Historic New Orleans Collection. A selection of the sketches from this collection was reproduced in the December 1963 issue of *American Heritage*.

Working their way up the Mississippi, Keeler and Waud were in St. Louis [22] when

[22] A St. Louis paper published an article describing the visit of Waud and Keeler to the American Wine Company, where they sampled the wines before descending into the vaults where the wine was manufactured: "... Mr. Waud, the clever artist who, with pencil, is photographing all the salient points and characteristic features of our municipal body, and Mr. Keeler, who with the ready pen that indited the amusing 'Vagabond Adventures' ... accordingly determined to sketch the cellars where they (the wines) are made." William Dean Howells, onetime editor of the *Atlantic Monthly*, declared Keeler's book, *Vagabond Adventures* "not unworthy to be named with *Two Years Before the Mast*. ... I believe his book is worthier of more remembrance than it seems to enjoy" (*Harper's Magazine*, November 1900). Two years after his tour with Waud on the Mississippi, Keeler disappeared while on assignment as a newspaper correspondent in Cuba (1873). He was just thirty-three years old at the time.

news came to them of the great Chicago fire (October 9, 1871). The two rushed by train to Chicago to cover the story for *Every Saturday*, arriving there while the fires were still burning. The artist–reporter team spent a week in the devastated city.[23] A number of Waud's original sketches of the historic fire, the refugees, and aftermath appeared in *American Heritage* for August 1963 and are now a part of the collection of the Chicago Historical Society. Both collections again testify to Waud's special facility for architectual renderings.

[23] Waud's wartime colleague, Theodore R. Davis, was in Chicago at the same time, picturing the fire for *Harper's Weekly*.

XXV. "Along the Docks—New York—View from West Street." Waud's double-page drawing engraved in *Harper's Weekly*, September 4, 1869 (here greatly reduced) presents a view looking north from Pier 7 on West Street with the Hudson River in the background. A great bustle of activity along the waterfront is evident in this superbly detailed panorama.

XXVI. Alfred Waud's personal invitation to President Grant's inauguration reception and dance, March 4, 1869. Waud's versatility as an artist is well demonstrated in his elaborate design for the invitation card. (Malcolm F. J. Burns Collection)

The untimely demise of *Every Saturday* [24] came as a blow to Waud, who at forty-three had undoubtedly pinned his professional hopes for the future upon that periodical's success in competing with *Leslie's* and *Harper's*. A news item of 1872 reported:

> A. R. Waud, the artist, having got over the death of *Every Saturday*, is now associated with Appleton's new Publication, *Picturesque America*. He has reached St. Louis again in search of subjects for illustration. Having pictured Pittsburgh, Cincinnati and Louisville, he will next pass up the Mississippi, make a raid into the Sioux country, "do" Duluth, and return by way of the great lakes and Chicago.

As noted above, Waud returned once more to the South and West in 1872 to execute a series of drawings for the handsome two-volume publication *Picturesque America*, edited by William Cullen Bryant and published by D. Appleton and Co. (1872–1874). This ambitious work was illustrated by a number of the most prominent artists

[24] The last article by Keeler and Waud for *Every Saturday*, "St. Louis, an excursion to Iron Mt. and the mineral regions—the end of the Mississippi Expedition," appeared in the December 9, 1871, issue.

61

XXVII. Joseph Keppler of the German-language *Puck* made this sketch of Alf Waud and writer Ralph Keeler while the artist-reporter team was in St. Louis in 1871 on assignment for *Every Saturday*. Waud, in bowler derby and sporting a flaring mustache, is characteristically shown sketching along the banks of the Mississippi River. (Malcolm F. J. Burns Collection)

of the day. Waud's many drawings encompassed views on the Ohio River, the lower and upper Mississippi, a "glance" of the Northwest, and Mammoth Cave, Kentucky. They included precise delineations of Pittsburgh and Cincinnati, New Orleans, and the burgeoning cities of St. Louis, Rock Island, Davenport, Dubuque, La Crosse, St. Paul and Minneapolis, Chicago, Milwaukee, Kenosha, and Racine. In August 1872 Waud proceeded from Duluth, Minnesota, to Bismarck, North Dakota, along the Northern Pacific Railroad, then under construction. The original drawings made on this trip, together with a thirty-seven-page manuscript describing the journey, are, at this writing, in the Malcolm F. J. Burns collection. Waud's drawings published in *Picturesque America* were reproduced in first-rate wood engravings and at least one steel engraving (Illustration XXVIII).

The artist proved to be a popular figure wherever he went. The following complimentary article appeared in 1872 in a Dubuque paper while Waud was on assignment for *Picturesque America*:

ALFRED R. WAUD, a gentleman whose name is familiar to all our readers who

are to any extent familiar with the better class of illustrated periodicals of the last ten years, has been in Dubuque for two or three days past. His errand among us is to sketch some of the finest portions of our beautiful scenery, for the benefit of a new work in process of publication, to be entitled "Picturesque America." He has taken a sketch of the scenery below Dubuque, including the winding river and the alternately approaching and receding bluffs; one of the scenery above the city; one from Third street Bluff, the central object in this sketch being the railroad bridge and surroundings; one of Kelly's bluff, including the Kelly hut; and one or two others. From these it is probable that a couple will be chosen to embellish the forthcoming volume, "Picturesque America." Mr. W. leaves on Monday's steamer for Lake City, St. Paul, Duluth, and points westward.

Mr. Waud has spent his time while in Dubuque in attending to his artistic duties rather than in making acquaintances, but he is one of those frank, cordial, companionable, yet unassuming men who cannot spend three days in a city of this size without finding by the time he gets ready to leave that he has made friends, to whom his society has been a pleasure, and who part from him with regret. He expresses himself much pleased with Dubuque, and half promises to return at some future time, more for pleasure and less for business. When that time comes, he will find among us a glad and cordial welcome.

And from a Duluth paper the following item is taken:

Mr. A. R. Waud, an artist of much celebrity, is now in the city at the Clark House. He came to the north-west to delineate some of our great scenery for D. Appleton & Co's work "Picturesque America," and will probably take back with him, among other sketches, a view of Duluth, taken from some position on Minnesota Point. Hitherto all the engraved views of the city have been from the hillside, thereby showing only the harbor and but a small portion of the city. In case Mr. W. sketches our town from the Point, a splendid picture will be the result.

Waud's drawings continued to emphasize his talent toward nautical subjects in sketches such as "Winter Scenes on the New Jersey Sea-Board (*Harper's*, 1868), the waterfront at New Orleans, and a view of vessels on Lake Michigan in *Picturesque America*. In 1886 *Harper's New Monthly Magazine* published an article illustrated with Waud's beautifully detailed drawings of historic ships, and as late as 1890 his drawing, "Magellan's Ships," appeared in that same periodical (Illustration XXIX).

Following his return from the Northwest, Waud resided briefly in Bethlehem, Pennsylvania (1873–1874). The impression he made upon his Pennsylvania neighbors is touchingly conveyed in this notice from a Bethlehem paper of an uncertain date:

—A. R. Waud, Esq., artist, so well and favorably known, socially and professionally, in Bethlehem, which he has made his home for a couple of years, is about to leave us, and take up his residence in "the metropolis," New York City. We are very sorry to lose Mr. Waud from among us, and hope that in the great city he will not forget us country folks, and will come and see us in our sylvan retreat as often as possible—in fact, oftener. The companionship of such a one as Mr. Waud, who has such store of anedote and experience, and such an acceptable way of telling them, is just what one does not come across every day. Come soon and often, friend Waud.

Note the similarity in the sentiment expressed in the above item and that published in the Dubuque paper in 1872.

In the latter 1870s Waud was working as a free-lance illustrator, occupying a studio at 896 Broadway, New York City. During the Cleveland-Blaine presidential campaign of 1884 he stepped briefly out of character and entered the field of political caricature, drawing pro-Blaine pictures for *Munsey's Weekly*. He undoubtedly prospered in his profession in the years after the war, for he maintained a twenty-two-room home in New York with black servants and a governess for his four children, all of whom later attended boarding schools in Pennsylvania. He was among the early exhibitors at the National Academy of Design, and, according to *Appleton's Annual Cyclopedia and Register of Important Events of the Year 1891*, was one of the first artists in the country to paint his illustrations in black and white.

When the *Century Magazine* embarked upon its prestigious "war series" during the years 1883 to 1887, Waud was one of the many contributing artists. The popularity of the articles led to their publication by the Century Company in four impressive volumes, *Battles and Leaders of the Civil War*. The drawings were engraved

XXVIII. Steel engraving by D. G. Thompson from a sketch by Alfred Waud of the New Orleans waterfront, published in *Picturesque America*, Vol. I, 1872. Note the steamboat *Natchez* in the right background.

XXIX. Magellan's ships were pictured by Alfred Waud in *Harper's New Monthly Magazine* in August 1890, shortly before the artist's death.

by some of the country's best craftsmen (Plates 24, 56 and 88), and it must have been particularly gratifying to Waud finally to see his efforts so well reproduced after the comparative crudity of the newspaper woodcuts made during the war years. By this time the engraver's art was approaching its artistic apogee; soon it would vanish altogether with the advent of the photoengraving process. Major General Henry E. Davies wrote to Waud, then living in South Orange, New Jersey, commending him on his drawing of the cavalry action at Paineville on April 5, 1865, which appeared in the Century series (Illustration XXXI):

> As it was my good fortune to command the U. S. Forces engaged in that affair you may know that it gives me great pleasure to find that the units of the day had been so well described by your pencil . . . and till now I was unaware that an artist had been with the troops nor could I have thought it possible in the sharp fighting and rapid movements of the day that any opportunity could have been found for the exercise of your talent. . . .

When George B. McClellan's memoirs were published in 1887 (*McClellan's Own Story*), five of Waud's drawings appeared in that work. During this same period the

XXX. Alfred R. Waud at work in his studio, probably in New York at 896 Broadway, which he occupied during the years 1875–1881. (Malcolm F. J. Burns Collection)

XXXI. "Capture of Guns and the Destruction of a Confederate Wagon-train at Paineville, April 5, [1865] by Davie's Cavalry Brigade of Crook's Division." This pen drawing by Waud, which appeared in the Century series *Battles and Leaders of the Civil War*, was the subject of General Davies' letter to Waud in 1888.

Western & Atlantic R. R. Co. published *Mountain Campaigns in Georgia or War Scenes on the Western & Atlantic,* a booklet designed to promote travel by veterans who had campaigned in the South during the war. Waud was the logical choice to produce the battle illustrations that appear throughout the book. While he had never been in the heartland of the South during the war, his drawings of the battles of Resaca, Kenesaw Mountain, New Hope Church, among others, indicate that he made careful studies of the actual sites in Georgia, recreating with creditable conviction the battle scenes and employing his firsthand knowledge of the war absorbed during those years during which he had covered the Virginia campaigns.

Nor was his talent confined to his own contemporary scene. The familiar "A. R. W." signature could be found in many publications of the period, identifying illustrations dealing with American history, comprising the early colonial era (Illustration

XXXIII), the American Revolution, the War of 1812, the Alamo, and other events. In 1876 his full-page re-creation of the Battle of Harlem Heights appeared in *Harper's*; showing an accurate representation of the terrain of upper Manhattan, the drawing remains the standard version of this battle of the Revolution, still reproduced in publications today.

Failing health plagued Waud's last years, and on April 6, 1891, his busy life came to an end at the age of sixty-two.[25] He had been on an extended sketching tour of Southern battlefields for the purpose of illustrating a new series of war narratives for Joseph M. Brown [26] when he died at the latter's home in Marietta, Georgia, after a brief illness.

Under the headline, "Heart Disease Carries Off a Well-Known Artist," *The Atlanta Constitution* said:

> Mr. Waud was well known in art circles, his specialty being the drawing of battle scenes. . . . He was genial and sociable by nature and very strong in his friendships. . . .

[25] *The New York Times*, April 10, 1891, published Alfred Waud's obituary and reported that the artist "was a resident of South Orange, N.J.: His wife died some years ago. He leaves three daughters, two of whom married artists—H. Pruett Share and Milton J. Burns, both men of this city." Waud's son, Alfred (1859–1936), who was estranged from his family, was omitted from the *Times* obituary.

[26] Son of former Governor Joseph E. Brown, and traffic manager of the Western and Atlantic R. R. Co.

XXXII. This pen-and-ink sketch by Waud shows Confederate General Longstreet's troops debarking from trains below Ringgold, Georgia, on September 18, 1863, prior to the Battle of Chickamauga. Waud re-created this scene for *Mountain Campaigns in Georgia or War Scenes on the Western & Atlantic*, issued by the Western & Atlantic R. R. Co. in the 1880s.

XXXIII. Tobacco ships on the James River, Virginia, was one of Alfred Waud's many historical illustrations which appeared in Bryant's *Popular History of the United States*. It is representative of the artist's careful study and attention to detail in depicting ships of historic vintage.

The above again attests to Waud's reputation for congeniality as evidenced in other accounts throughout his life. Both the *Constitution* and *The New York Times* reported that the artist's remains would, upon the arrival of his son-in-law, be sent to his home in South Orange, New Jersey. For some reason the removal of the body was never made and Waud was buried in the Episcopal cemetery in Marietta.

Two weeks before his death, Waud wrote from Marietta to his eldest daughter, Mrs. Milton J. Burns: "Sunday I went to Atlanta and dined at Gov. Brown's [27] with all the family except the wife and daughter of Julius Brown [28] at present in Europe." He went on to ask that his son-in-law send some of his photographic equipment that he had forgotten, and later in the letter he wrote: "Tonight I spend with Mr. Julius at his house in Atlanta. Feeling pretty well hope you are same regards to Burns your loving Dad, Alfred R. Waud."

Everything had interested him during his lifetime. An intelligent and perceptive man, he was undoubtedly fully aware that what he chronicled on the pages of his ever-present sketchbook would find a place in posterity. He and his fellow newspaper artists had witnessed and recorded the panoply of war, reconstruction, and the growing expansion of nineteenth-century America. A generation of readers of *Harper's Weekly* had explored their nation from their firesides through the eyes and words of "Special Artists" like Alf Waud. The historical record he has left, while not widely

[27] Joseph E. Brown, wartime governor of Georgia and at the time of Waud's visit a U. S. Senator and president of the Western and Atlantic R. R. Co. for whom Waud had illustrated the booklet *Mountain Campaigns in Georgia or War Scenes on the Western & Atlantic* in 1886.
[28] Also a son of Governor Joseph E. Brown.

known today, remains a monument to this tireless man with sketchbook and pencil, who galloped on "his big brown steed" along the battlefronts of Virginia, rode the Mississippi steamboats and Western railroads, explored Southern cities and bayous. As a profession, the "Special Artists" lasted for only half a century. Their breed has long since been replaced by the news photographer and the television cameraman, but in their time they were just as indispensable to the visual news coverage of the nation.

For years the name of Alfred R. Waud was virtually forgotten. Then, in 1937, Professor J. C. Randall used some of Waud's original drawings in *The Civil War and Reconstruction*, and in 1947 the Library of Congress publication of *An Album of American Battle Art: 1755–1918* reproduced sixteen drawings by Alfred and three by William Waud. In 1952 Hirst D. Milhollen and Milton Kaplan of the Library of Congress assembled in *Divided We Fought* a wealth of Civil War photographs and original field sketches, and many by Waud were reproduced in their original form for the first time. With the great volume of illustrated publications on the Civil War which followed through the centennial years and into the present, Alf Waud's reputation has come full circle.

XXXIV. The grave of Alfred R. Waud in Marietta, Georgia. (Photo courtesy of Mr. Thomas Spencer, St. Petersburg, Florida)

EPILOGUE

In Gathland State Park, Maryland, high atop South Mountain at Crampton's Gap, stands a monument perhaps unlike any other in the world. It is the War Correspondents Memorial Arch, built in 1896 by George Alfred Townsend, correspondent for the New York *Herald* during the Civil War. Townsend built the arch upon his own tract of land on South Mountain and on it inscribed these words:

> To the Army Correspondents
> and
> Artists
> 1861–65
>
> Whose toils cheered the fireside
> Educated provinces of rustics into
> a bright nation
> of
> readers
> and gave incentive to narrate
> distant wars and explore dark lands.

Carved on four sides of the monument are the names of 157 correspondents and artists of the Civil War; among the names are those of Alfred and William Waud.

Part II
THE PLATES

Note

For the sake of brevity in the descriptions accompanying the Plates, *Harper's Weekly* is frequently referred to as *Harper's*. The abbreviations given are: NYIN for the *New York Illustrated News*, HW for *Harper's Weekly*, and Eng, Engraved. All of the drawings are from the Collection of the Library of Congress, except those that are individually specified in the descriptions.

PLATE 1 Washington Street, Boston, c. 1858.

INSCRIBED: "View in Washington St. from the old South, Boston" INSCRIBED BOTTOM: "Plenty of carriages and people."

(M. & M. Karolik Collection, Museum of Fine Arts, Boston, Massachusetts)

PLATE 2 The Washington Navy Yard, April 1861. (Eng NYIN April 13, 1861)

INSCRIBED: "Washington Navy Yard 1861." The artist has indicated the U. S. S. *Pensacola* at the far left.

When Waud made this sketch early in April 1861, the outbreak of civil war was only days away. The U. S. Navy, with only a handful of ships in commission, was ill-prepared for hostilities. The activity depicted here at the Washington Navy Yard suggests the initial urgency with which the Federal government had begun to build and refit its ships of war. On the other hand, the South had no navy at all, and in the following years the blockade of Southern ports by the Federal fleet would seal the fate of the Confederacy.

PLATE 3 Funeral of Colonel Vosburgh, May 21, 1861. (Eng NYIN June 8, 1861)

INSCRIBED: "funeral of Col Vosburgh. The hearse approaching the R.R. Depot." INSCRIBED ON BACK: "The hearse was black. 4 white horses. Staff officers of the 12 reg walking at the Side. Colonel's black horse led after coffin covered with flag. sword and hat laid on top. and two wreaths of flowers—drummers and musicians on left red coats—drums covered with black cloth—Soldiers on the opposite Side—without arms. on right mounted Rhode Island officers—and in front R. I. band—in blue Shirts belted round waist—crowd behind on hacks, stages Etc.—have another sketch of funeral service send it tomorrow."

Waud sketched the funeral procession as it passed from the Navy Yard toward the railroad depot on the Mall below the Capitol, seen in the background with the dome still unfinished. Vosburgh, commanding the 71st New York Regiment, known as the Second Excelsior Brigade, had sailed from New York for the defense of Washington in April. A month later he was dead of a lung hemorrhage at the Navy Yard in Washington. A leading New York citizen and the first officer casualty of New York volunteers, Vosburgh was buried with military honors in New York City.

PLATE 4 General Winfield Scott and Staff, July 1861. (Eng NYIN July 22, 1861)

The *News* reported that Scott, "the old hero, who with a graceful willingness to gratify public curiosity, has permitted Mr. Waud to take a sketch of him in his office at Washington. In giving his rather unwilling consent, the veteran good-humoredly told our artist that he 'would lief be taken out and shot at ten paces, as be sketched.' "

Left to right in Waud's drawing: Lieutenant Colonel George Washington Cullum, Lieutenant Colonel Schuyler Hamilton, General Winfield Scott, and Colonel Henry Van Rensselaer.

PLATE 5 President Lincoln and General Scott Reviewing Troops on Pennsylvania Avenue, July 4, 1861.

INSCRIBED: "President Lincoln and Genl Scott reviewing a three-year regiment on Penna Ave. 1861."

In deference to his age and health, General Scott is the only personage in the reviewing stand who is seated. Note Waud's very careful delineation of the White House and surroundings.

PLATE 6 Scouting Party of Schenck's Ohio Regiment near Fairfax Court House, June 1861. (Eng NYIN July 13, 1861)

INSCRIBED ON BACK: "The Ohio camps near Vienna in a valley through which runs a railroad on which this skirmish took place a beautiful and romantic spot. but hardly a safe position against surprise— in the foreground is a scouting party in search of secessionists. A great deal of this part of Virginia seems to be good farming land—a great deal of wheat and other cereals being grown."

In June 1861 scouting parties pushed into Virginia, feeling out the Confederate forces near Fairfax Court House. These troops depicted by Waud are wearing havelocks, popular during the early part of the war, attached to their caps.

PLATE 7 Burnside's Brigade at the First Battle of Bull Run, July 21, 1861. (Eng NYIN August 5, 1861)

This was Waud's first encounter with the problems of sketching a battle scene under fire. Note the assurance of his later battle sketches as compared with this first such drawing. The action depicted here occurred in the Matthews Hill area of the battlefield during the morning of July 21. While the outcome of the conflict seemed at this time to favor the Union army, the day's fighting at Bull Run (Manassas) ended with the rout of Federal forces and a complete Confederate victory.

PLATE 8 First Day's Action at Hatteras Inlet, August 28, 1861. (Eng NYIN September 16, 1861)

INSCRIBED: "Capture of the Forts at Hatteras inlet—First Day, fleet opening fire and troops landing in the Surf." INSCRIBED ABOVE WARSHIPS, L. TO R: "Minnesota—Cumberland—Wabash—Susquehannah." SIDEWHEELER INSCRIBED: "Harriet Lane." FORTS TO RIGHT INSCRIBED: "Fort Clark—Fort Hatteras." The troops on the beach are Hawkins' Zouaves (9th New York).

PLATE 9 Landing of Union Troops at Hatteras under Cover of the Fleet, August 28, 1861.

This painting by Alfred Waud in black, white, gray wash, and gouache was based upon the sketch (Plate 8) made on the spot. It is owned by the Franklin D. Roosevelt Library, Hyde Park, New York. A second Waud painting in the F. D. R. Library is entitled "Opening of the Naval Attack on Port Hudson." Both pictures are small, 7¾" × 11" and 8½" × 12¾" respectively, and were painted in the 1880s for the Century's series *Battles and Leaders of the Civil War*. Both were engraved in that work, Vols. I and III. (Published through the courtesy of the Franklin D. Roosevelt Library)

PLATE 10 Flag of Truce—Near Norfolk, Virginia, September 1861. (Eng NYIN September 23, 1861)

INSCRIBED: "Flag of Truce."

Waud wrote (NYIN September 23, 1861): "While at Fort Monroe, a courteous invitation from Capt. Davis, the efficient Provost Marshal of the station, enabled me to accompany a flag of truce sent up to Norfolk, in charge of Lieutenant Crosby, for the purpose of conveying some ladies and children to their relatives in that *charming city*." He goes on to describe one of the ladies he sketched being transferred to the Confederate craft: "It may be permitted to say that she was quite pretty, and one of Philadelphia's daughters, whose conjugal affection prompted her to seek her husband, even in the land of rebellion. May he prove worthy of her."

PLATE 11 General Sickles Reconnoitering along the Potomac, September (?) 1861.

INSCRIBED: "General Sickles and Staff on a reconnoitering expedition along the banks of the Potomac."

The civilian riding beside Sickles is believed to be Frank Vizetelly, staff artist for the *Illustrated London News*, who later transferred his sympathies to the South and thereafter pictured the war from the Confederate side. (Note Sala's reference to Vizetelly, page 11.)

PLATE 12 Sutler's Cart at Bailey's Cross Roads, Virginia, November 1861. (Eng NYIN December 21, 1861)

Waud wrote (NYIN December 21, 1861): "The novel sight of a handsome young woman attended by a quiet negro, driving her own team, and selling her wares in person with a pistol buckled to her waist, as well as the picturesque groups about, induced me to out album and make the sketch which accompanies this. Cider, apples, pies, cakes, and tobacco, seemed to be her staple, and although perfectly good humored, and occasionally showing her white teeth in a charming smile, there was an air about her which told plainly that any impertinence would be apt to draw the fire of her little pistol upon the culprit. As for the soldiers they appeared perfectly respectful and kind to her, and I hope she is realizing enough by the venture to make up for the rough nature of her vocation."

Sutlers accompanied the army in the field or in garrison selling food, drink, and supplies to the troops—a Civil War version of the modern Army PX. The Articles of War prescribed that "persons permitted to sutle shall supply the soldiers with good and wholesome provisions or other articles at a reasonable price."

PLATE 13 Thanksgiving in Camp, November 28, 1861.

INSCRIBED: "Thanksgiving in Camp sketched Thursday 28th 1861."

Though not identified, this is possibly the camp of General Louis Blenker, with whose division it is known that Waud spent some time in the latter months of 1861.

PLATE 14 Grand Reception at the White House, January 1862. (Eng HW January 28, 1862)

This White House reception, given by President and Mrs. Lincoln on January 1, 1862, was attended by cabinet members and families, diplomatic corps, justices of the Supreme Court, and officers of the Army and Navy. *The New York Times* commented: "A striking feature of the scene was the great number of gay uniforms visible—Generals, Colonels and Majors were plenty as blackberries, while Captains and Lieutenants were multitudinous. If our soldiers prove as useful as they are ornamental, nothing more could be desired of them." (NYT, January 3, 1862)

This was the first of Waud's drawings to appear in *Harper's Weekly*. In it he has carefully portrayed a number of prominent political and military figures. At the left are the President's secretaries, John Hay and John G. Nicolay. Next are General Irvin McDowell and Colonel Ward H. Lamon, then President Lincoln. Immediately to the left of Mrs. Lincoln (in dark dress, her back to the reader) are General George W. Cullum and Colonel John Jacob Astor III. Mrs. Lincoln is greeting Secretary Salmon P. Chase and his daughter, Kate Chase Sprague. Behind them is Miss Cameron, daughter of the Secretary of War, Simon Cameron. In the small group in the foreground, Henri Mercier, the French Minister, converses with Generals John J. Peck and William B. Franklin. Observing them is General Samuel P. Heintzelman, standing next to General George A. McCall, who is seated at right. (M. & M. Karolik Collection, Museum of Fine Arts, Boston)

PLATE 15 The Battle of Kernstown, March 15, 1862. (Eng HW April 12, 1862)

INSCRIBED: "Battle of Winchester. Decisive charge upon the rebels at the stone wall." "Many of the soldiers without caps."

Waud wrote in *Harper's:* "The rebel position was a parallelogram, inclosed by a stone wall on two sides and a rail fence and thicket of trees on the other. In the picture the front of the wall is seen crossing the ground from right to left, the thicket being visible in the distance on the rise. In front of this wall our troops had to advance across a field of wheat for 400 yards, exposed to a galling fire, but with invincible courage they carried it, and rebels retreating in a panic as soon as the wall was reached.

"One or two was bayoneted, and there was a fist-fight for a moment between one of them and a soldier of the Union force—the rest fled in confusion, hotly pursued by Tyler's brigade; and two guns, hitherto masked, opened upon our men from a small clump of trees seen in the centre of the lot. These were quickly captured by a brave few, headed by Major Schreiber, of Bank's staff, and then the rout was complete, night only saving the rebels from the fierce pursuit to which they were subjected. Most of the men killed at the stone wall were shot in the head, some of the bullets passing through two men before their work of death was over. The precision of the Union men's fire was unprecedented in the annals of modern warfare."

Waud called his sketch the Battle of Winchester; actually, it was officially known as the Battle of Kernstown, named for a small town just four miles south of Winchester, fought between Federal forces under General James Shields and Confederates under Stonewall Jackson.

PLATE 16 McClellan Crossing Bull Run at Blackburn's Ford, March 1862. (Eng HW March 29, 1862)

INSCRIBED: "Genrl McClellan and Staff—accompanied by the 5th Cavalry crossing Bull Run at Blackburns Ford."

A correspondent for the Philadelphia *Inquirer* described the scene: "About noon Generals M'Clellan and M'Dowell, with their staffs, and two thousand cavalry for an escort, came up and took the road to Manassas. We fell in with them and followed on down to Manassas. All along to the left of the road was one continuous string of huts, tents, and forts, all empty now—not a human being or animal showed themselves—not a sound save the clatter of the horses hoofs, and shrill tones of the bugles, or the loud order of the officers."

PLATE 17 McClellan's Army Landing at Hampton, Virginia, March 1862. (Eng HW September 6, 1862)

This drawing, made at the beginning of McClellan's drive up the James Peninsula, has been erroneously ascribed to John R. Chapin. The sketch is indisputably Waud's, although his signature does not appear on it. It was engraved in *Harper's*, September 6, 1862, long after the event it depicts, and was deceptively entitled "The Army of the Potomac Arriving at Yorktown from Williamsburg."

PLATE 18 Lieutenant Custer Wading in the Chickahominy, May 1862.

Waud's sketch shows young Lieutenant George A. Custer testing the fordability of the Chickahominy on order of General John G. Barnard, Army Chief of Engineers, on May 22, 1862. Custer waded across, located the positions of enemy pickets on the far side, and returned to Barnard (seated on a horse in the sketch). McClellan, impressed by Custer's daring, asked him to become his staff aide-de-camp. Custer would become a frequent subject for Waud's pencil throughout the rest of the war. (Plates 87, 93, and 102)

PLATE 19 Rebels Leaving Mechanicsville, May 24, 1862 (Eng HW June 21, 1862)

INSCRIBED: "Rebels leaving Mechanicsville. Union batteries shelling the Village." INSCRIBED AT TOP: "Make the rebels look very rough"

Brigadier General John W. Davidson reported the assault on Mechanicsville: "At daylight in the morning I attacked the village. The enemy opened upon us at the same time with their artillery and infantry who fired upon our advanced lines from the houses, barns, trees, and hedges . . . I threw forward my whole line of skirmishers, pushed forward my pieces upon the enemy . . . and concentrating my fire, silenced their pieces and drove them out of the houses . . . the Seventy-seventh New York Volunteers, Col. James B. McKean commanding, . . . was thrown into it upon the heels of the retreating enemy, who in their flight left behind them a part of their knapsacks and a flag of one of their regiments." (Official Records, XI, pt. 1, p. 655)

PLATE 20 Battle of Hanover Court House, May 27, 1862. (Eng HW June 21, 1862)

INSCRIBED: "Commencement of the battle of Hanover Ct. House 1:45 PM" Notations locate the positions of "Gen Porter & Staff, 6th Regular Cavalry, The Rebel Army, Benson's Horse Artillery, and Johnson's infantry."

PLATE 21 Burying the Dead and Burning the Horses at Fair Oaks, June 2, 1862. (Eng HW July 19, 1862)

INSCRIBED: "Fair Oaks after the battle. burying the dead and burning the horses. Tuesday 3rd June."

Waud wrote in *Harper's*: "Fairoaks is a railroad station, used principally as a depot to supply the engines with wood, which is cut in large quantities in the swamps and woodlands of the vicinity. It takes its name from the plantation near by, which is called Fairoaks, from the group of green oak-trees which surround the twin-houses represented in the picture."

PLATE 22 Confederates Capturing Disabled Guns at Gaines's Mill, June 27, 1862.

INSCRIBED: "Confederates Advancing to the capture of disabled guns—Gaines Mills."

Major General Fitz John Porter might have been describing Waud's drawing when writing in *Battles and Leaders of the Civil War* of the hard-fought Battle of Gaines's Mill: "... The right, seeing our disaster, fell back united and in order, but were compelled to leave behind two guns, the horses of which had been killed. The troops on the left and center retired, ... often turning back to repulse and pursue the advancing enemy."

98

PLATE 23 Franklin's Corps Falling Back near Trent's House, June 29, 1862. (Eng HW August 16, 1862)

INSCRIBED: "Scene Near Trent's House, Formerly M'Clellan's Head-Quarters—Franklin's Corps Falling Back, June 29, 1862."

Waud's description in *Harper's:* "This was a scene to be remembered. It occurred at two A.M. on Sunday, 29th June. The clearing was filled with wagon-trains, shown up by the glare of fires lighted for the destruction of such stores as it was impossible to convey with the army. Among these the artillery and infantry steadily moved to take up positions for their defense. By the dull glow of the fires guns in position came into sight formed across the field; and occasionally, when a box of cartridges or other inflammable material would explode, the whole scene would be illuminated brightly in all its detail; artillery moving: guns in battery, with the tired cannoniers sleeping around them; wagon-trains forming for a move; soldiers burning stores, *con amore*, that 'Johnny Reb' might not profit by them; stragglers and sick working their weary way along, and much more, making a scene of the most dramatic character."

PLATE 24 The Retreat from the Chickahominy

This engraving, based upon Waud's sketch (Plate 23), appeared in *Battles and Leaders* (Vol. II) and was further described: "The scene is near McClellan's headquarters at Dr. Trent's farm, before daylight on Sunday, June 29; the Sixth Corps (Franklin's) is falling back, the fires are from the burning of commissary stores and forage; the artillery in position covers the approaches from the Chickahominy, the artillerymen resting underneath the guns. The regiment in the middle-ground is the 16th New York, who wore straw hats, and were partly in consequence, such conspicuous targets for the enemy that in the Seven Days' fighting they lost 228 men."

OPPOSITE, ABOVE:

PLATE 25 Graham's 5th Excelsior Regiment Shelled While Being Reviewed, June (?) 1862.

INSCRIBED: "Col. Grahams 5th Excelsior reg. U.S.V. Shelled while being reviewed by Gen. Sickles."

General Sickles is identified on "white horse" in right background. Note the enemy shell ploughing into the earth in the foreground.

PLATE 26 U. S. Gunboats Shelling the Confederates at Battle of Malvern Hill, July 1, 1862.

INSCRIBED: "Gunboats shelling the enemy after the battle of Malvern hill. Sketched from McClellans headquarters." INSCRIBED UPPER RIGHT: "General McClellan went aboard while I was sketching to change the position of the gunboats that were shelling *our* infantry."

PLATE 27 Battle of Malvern Hill, July 1, 1862.

INSCRIBED: "Battle of Malvern Hills, fought on Thursday July 1st. in which the federal forces gained a complete victory over the rebel army led by Genl's Magruder—and Jackson. Right wing of 5th corps—Genl Porter."

General McClellan wrote of Malvern Hill: "About seven o'clock, as fresh troops were accumulating in front of Porter and Couch, Meagher and Sickles were sent with their brigades . . . to reinforce that part of the line and hold the position . . . Until dark the enemy persisted in his efforts to take the position so tenaciously defended; but, despite his vastly superior numbers, his repeated and desperate attacks were repulsed with fearful loss, and darkness ended the battle of Malvern Hill, though it was not until after nine o'clock that the artillery ceased its fire. The result was complete victory." (*McClellan's Own Story*, 1887)

Battle of Malvern Hills, Va, on Sunday July 1st in which the federal forces gained a complete victory over the rebel army, led by Gen'ls Magruder and Jackson. Right wing of 5th corps Genl Porter

PLATE 28 Skedaddler's Hall, July 3, 1862.

INSCRIBED: "Sketch in Sutler's store Excelsior Brigade July 3rd." INSCRIBED UPPER RIGHT: "Skedaddlers Hall, Harrison's Landing."

Harrison's Landing on the James River was the base to which McClellan moved his army before his victory at Malvern Hill, the final battle of the Peninsular campaign. The "Excelsior Brigade" (72nd New York Regiment) performed gallantly at that battle on July 1. "Skedaddler's Hall" was apparently the nickname for this combination sutler's store and rest and recreation center. A wealth of detail abounds in the sketch; all the men appear to be officers, their laundering being done by black women. Note that the figure seated to the left of the doorway bears a close resemblance to Waud and was probably intended as a self-portrait. Two days after making this sketch Waud wrote his letter to "Friend Paul" (page 35).

This enlarged portion of the accompanying drawing is Waud's self-portrait.

104

105

PLATE 29 Pope's Defeat at the Second Battle of Bull Run, August 30, 1862.

INSCRIBED: "Saturday, August 30th 1862. Defeat of the Army of Genl Pope at Manassas on the old Bull run-battle ground."

Writing in *Battles and Leaders*, Confederate General James Longstreet recalled the Union defeat: "As the cannon thundered the [Federal] ranks broke, only to be formed again with dogged determination. A third time the batteries tore the Federals to pieces, and as they fell back under this terrible fire, I sprung everything to the charge . . . Farther and still farther back we pressed them, until at 10 o'clock at night we had the field; Pope was across Bull Run, and the victorious Confederates lay down on the battleground to sleep, while all around were strewn thousands—friend and foe, sleeping the last sleep together."

PLATE 30 The Confederate Army Crossing the Potomac by Moonlight, September 1862.

INSCRIBED: "Previous to Antietam. Rebels crossing the Potomac. union scouts in foreground."

Waud's sketch depicts the crossing of the Potomac at White's Ford by Lee's army, Stonewall Jackson in the lead, on September 5, 1862. "The passage of the river by the troops marching in fours well closed up, the laughing, shouting, and singing, as a brass band in front played 'Maryland, my Maryland,' was a memorable experience," wrote Colonel Henry Kyd Douglas (C.S.A.)

PLATE 31 The 1st Virginia Cavalry, September 1862. (Eng HW September 27, 1862)

This drawing of the 1st Virginia Cavalry, a part of General Fitzhugh Lee's brigade of five regiments, was a coup for *Harper's*; their staff artists seldom came into such close contact with the enemy in the field. How Waud came to find himself "detained" by the Confederates we are not told; however, his pass through the lines is preserved. It reads: "The bearer Alfred R. Waud having entered the Confederate lines under a flag of truce has permission to return to the Federal lines." It is signed by John T. Wilson, Capt., Co. A, 50th Rgt., Georgia Volunteers at Centreville, Virginia.

Waud wrote: "Being detained within the enemy's lines, an opportunity occurred to make a sketch of one of the two crack regiments of the Confederate service. They seemed to be of considerable social standing, that is, most of them—F.F.V.'s, so to speak, and not irreverently: for they were not only as a body handsome, athletic men, but generally polite and agreeable in manner. With the exception of the officers, there was little else but homespun among them, light drab-gray or butternut color, the drab predominating; although there were so many varieties of dress, half-citizen, half-military, that they could scarcely be said to have a uniform. Light jackets and trousers with black facings, and slouched hats, appeared to be (in those cases where the wearer could obtain it) the court costume of the regiment. Their horses were good; in many cases, they told me, they provided their own. Their arms were the United States cavalry sabre, Sharp's carbine, and pistols. Some few of them had old swords of the Revolution, curved, and in broad, heavy scabbards. Their carbines, they said, were mostly captured from our own cavalry, for whom they expressed utter contempt—a feeling unfortunately shared by our own army. Finally, they bragged of having their own horses, and, in many cases of having drawn no pay from the Government, not needing the paltry remuneration of a private. The flag represented in the picture is the battleflag. White border, red ground, blue cross, and white stars."

PLATE 32 Burning of Mumma's Houses and Barns During the Battle of Antietam, September 17, 1862. (Eng HW October 11, 1862)

INSCRIBED: "Burning of Mr. Muma's houses and barns at the fight of the 17th Sept." "Rebel caisson blowing up"

Writing in *Harper's*, Waud described the scene: "The burned mills are seen in the centre of the picture. In the foreground is the Twelfth New York Volunteers, protected in the bed of the canal (from which most of the water has been run off) from the fire of the enemy's sharp-shooters, which the color-bearer is endeavoring to draw. These colors, presented to the regiment by the ladies of Syracuse, bear marks of shot and shell, and are so battle-stained and torn that it would be difficult for the before-mentioned ladies to recognize them now."

PLATE 33 Skirmish between the 14th Brooklyn and Confederate Cavalry at Antietam, September 17, 1862.

INSCRIBED: "Skirmish between the Brooklyn 14th and 300 Rebel Cavalry."

Brevet Brigadier General Rufus B. Dawes wrote of the 14th Brooklyn Regiment at Antietam: "The Fourteenth Brooklyn Regiment, red-legged Zouaves, came into my line on a run, closing the awful gaps. Now is the pinch. Men and officers of New York and Wisconsin are fused into a common mass in the frantic struggle to shoot fast. Everybody tears cartridges, loads, passes guns or shoots. Men are falling in their places or running back into the corn. The soldier who is shooting is furious in his energy and eagerness to win victory. Many of the recruits who are killed or wounded only left home ten days ago." (*History of the Fighting Fourteenth*, 1911)

PLATE 34 Citizen Volunteers Assisting the Wounded on the Field of Antietam, September 18, 1862. (Eng HW October 11, 1862)

INSCRIBED: "Citizen Volunteers assisting the wounded on the field of Battle"

A New York *World* correspondent wrote: "The severest fighting of the war was followed by the most appalling sights upon the battle-field. Never, I believe, was the ground strewn with the bodies of the dead and dying in greater numbers or in more shocking attitudes."

PLATE 35 Carrying off the Wounded after the Battle. Engraving from *Harper's Weekly*, October 11, 1862

When *Harper's* engraved Waud's sketch (Plate 34), the wounded soldier on the operating "table" was discreetly turned around to hide the sight of the amputated limb portrayed in the original drawing.

PLATE 36 Pleasonton's Cavalry Deployed as Skirmishers, October (?) 1862. (Eng HW November 22, 1862)

INSCRIBED: "Pleasontons Cavalry deployed as Skirmishers"

Waud's drawing illustrates the manner in which Federal cavalrymen of General Alfred Pleasonton's command advanced, feeling out the enemy's strength.

PLATE 37 Crossing the Pontoon Bridge at Berlin, Maryland, November (?) 1862.

INSCRIBED: "Crossing the Pontoon bridge at Berlin."

Alexander Gardner photographed this pontoon bridge in November 1862 and commented: "Here McClellan had his headquarters after the battle of Antietam, and the troops crossed into Virginia, marching down through Loudon to Rectortown and Warrentown, and thence to Fredericksburg." (*Gardner's Photographic Sketch Book of the War*, 1866) (M. & M. Karolik Collection, Museum of Fine Arts, Boston)

PLATE 38 Stripping a Rail Fence for Firewood, November (?) 1862.

INSCRIBED: "Stripping a rail fence for fires."

In *Harper's*, December 13, 1862, Waud wrote of this common practice among soldiers on the march: "It is rather comical to notice the rapidity with which neighboring rail-fences are demolished when a halt is ordered. The men directly organize a rail brigade—a kind of rail-ery not at all relished by the unfortunate natives whose fences make such desirable fuel, being cut and dried for the purpose."

Waud redrew this scene in pen and ink for *Battles and Leaders* (vol. IV) under the title, "Incident of Sherman's March—The Fate of a Rail Fence."

OPPOSITE:
PLATE 39 On the Burned Railroad Bridge at Fredericksburg, November–December, 1862. (Eng HW December 13, 1862)

Waud described this sketch in *Harper's*: "This is a favorite spot for the soldiers of either army to meet within speaking distance and exchange remarks, frequently of an uncomplimentary character.

Proposals for all sorts of exchanges (impossible of accomplishment) are made—such as offers to barter coffee or tea for whisky or tobacco, gray coats for blue ones—the rebels walking about in the clothes they have taken from Uncle Sam's men prompting the proposal. The seceshers show a laudable anxiety to get New York papers for Richmond publications; a number of them have asked after their Commissary and Quarter-master (meaning Pope and M'Dowell), and they generally express a belief that they 'will whack the Union army now M'Clellan is gone.' To their inquiry of our men, 'How do you like Bull Run?' they receive for answer, 'What do you think of South Mountain?' Some witty remarks are made on both sides, but it usually ends in a general black-guarding. One of them told a Zouave that they should shortly come over to look after us. 'Yes,' he answered; 'so you will, under a guard.'"

Note the soldier waving a copy of *Harper's Weekly*.

PLATE 40 Building a Pontoon Bridge Under Fire at Fredericksburg, December 11, 1862.

INSCRIBED: "50th Engineers Building Pontoon bridge at Fredericksburg Dec. 11th."

PLATE 41 Sumner's Grand Division Crossing the Rappahannock, December 11, 1862. (Eng HW January 3, 1863)

INSCRIBED: "Fredericksburg—night of the 11th"

In the background are the burning houses of Fredericksburg and the ruins of the railroad bridge that appears in Plate No. 39.

PLATE 42 Attack on the Rebel Works at Fredericksburg, December 13, 1862. (Eng HW January 3, 1863)

INSCRIBED: "Attack on the rebel works Fredericksburg Dec. 13th."

This finely detailed drawing, probably made from a church steeple in Fredericksburg, shows a panorama of the battle fought on December 13 when Burnside threw his army in a frontal assault against Lee's works on Marye's Heights. The Marye mansion is indicated in the far background; the smoke of battle pinpoints artillery and infantry fire. The sketch is a fine example of the look of a major battle from a distant vantage point.

PLATE 43 Charge of Humphreys' Division at the Battle of Fredericksburg, December 13, 1862.
(Eng HW January 10, 1863)

Waud's account of the charge appeared on the first page of *Harper's* January 10, 1863:

"Against this magnificent defensible position, strong as Sebastopol . . . our troops were hurled all day . . . French and Sturgis led their divisions with patriotic determination to the enemy's rifle-pits . . . falling by hundreds . . . delivered its fire till the last cartridge was spent and nearly half its men killed and wounded. It retired as it came—over the open fields. After it came first Hancock's and then Howard's divisions, each charging more savagely than its predecessors, and holding the ground in from the rebel works while its ammunition lasted. By this time the sun had set behind the rebel fortifications. The crimson-edged clouds gleamed through masses of smoke, which almost obscured at times the placid sky, so peaceful in its quiet evening tints, and suggestive of the cessation of the day's labor. . . . The rebel fire breaks out with more ferocity than ever. For sweeping across the fields come the divisions of Generals Humphreys and Griffin. Onward, a forlorn hope, they advance—the ground encumbered by countless bodies of the fallen; knapsacks, blankets, guns, haversacks, canteens, cartridge-boxes, etc, strewed over the plain. Shot, shell, canister, shrapnel, and grape is hurled as they approach. By column of regiments, led by their generals, and without firing a shot, that noble band continues on. General Humphreys, dashing ahead to a small rise in the ground, takes off his hat to cheer on his men. With reckless ardor his men, rapidly closing on the double-quick, answer cheers

with cheers. Every member of the General's staff has been dismounted. The brave Humphreys himself has two horses shot from under him. . . .

"Humphreys' division has never been under fire till this battle. But against that awful hurricane of bullets no heroism can avail. The hillside appears to vomit forth fire, its leven glare flashing through the fast-thickening obscurity seems to pour with redoubled power upon our storming columns, till, being unable to stand up against it longer—although within eighty yards of the wall—the brave remnant, singing in the *abandon* of its courage, marches steadily back to the place where it formed for the charge, leaving its comrades in swathes upon the bloody ground, where, 'stormed at by shot and shell,' they had been cut down, whole ranks at a time, by that terrible fire."

PLATE 44 Gallant Charge of Humphreys' Division at the Battle of Fredericksburg. Engraving from *Harper's Weekly*, January 10, 1863.

Compare this woodcut from *Harper's* with the original sketch by Waud (Plate 43). The artist's "short-hand" interpretation of the foreground has been faithfully finished by the engraver. Many of Waud's Civil War drawings for *Harper's* were engraved by Henry L. Stephens, reproducing accurate copies of the originals.

PLATE 45 Signal Telegraph Machine and Operator, Fredericksburg, December 1862. (Eng HW January 24, 1863)

INSCRIBED: "Signal Telegraph Machine and operator—Fredericksburg."

122

Waud wrote: "The machine is a simple one, worked by a handle, which is passed around a dial-plate marked with numerals of the alphabet. By stopping at the necessary letters a message is easily spelled out upon the instruments at the other end of the line, which repeats by a pointer every move on the dial-plate. The whole thing is so simple that any man able to read and write can work it with facility."

PLATE 46 Signal Telegraph Train Used at the Battle of Fredericksburg, December 1862. (Eng HW January 24, 1863)

INSCRIBED: "The Signal Telegraph Train as used at the battle of Fredericksburg."

In Waud's words: "The wire & the instrument can be easily carried in a cart, which as it proceeds unwinds the wire, and, when a connection is made, becomes a telegraph office. Where the cart can not go the men carry the drum of wire by hand."

PLATE 47 The Mud March, January 21, 1863. (Eng HW February 14, 1863)

INSCRIBED: "Winter Campaigning. The Army of the Potomac on the move. Sketched near Falmouth—Jan. 21st."

"Twelve horses could not move a gun," wrote an eyewitness to Burnside's infamous "Mud March." "The wheels of vehicles disappeared entirely. Pontoons [shown on the right of the sketch] stood fixed and helpless in the roadway, the wheels out of sight . . ." And a Union cavalry bugler remembered: "It was terrible especially for Artillery horses, and many gave out . . . It was reported that the Johnnies called across [the river] that they would send over a Division to help us out." Note two rain-drenched soldiers in the drawing with their coffeepots slung from their muskets; also the dog mascot sharing in the miseries of the troops.

124

PLATE 48 Contrabands Coming into Camp, January 1863. (Eng HW January 31, 1863)

INSCRIBED: "An arrival in Camp under the Proclamation of Emancipation."

Of this sketch, Waud wrote in *Harper's*: "There is something very touching in seeing these poor people coming into camp—giving up all the little ties that cluster about home, such as it is in slavery, and trustfully throwing themselves on the mercy of the Yankees, in the hope of getting permission to own themselves and keep their children from the auction-block. This party evidently comprises a whole family from some farm: the mule cart, without a particle of leather about its rope harness, and with a carpet thrown over it for wagon-cover, is unique in its dilapidation. The old party with the umbrella is a type. Down on the Peninsula it appeared constantly on the Sabbath. No matter how fine a day, the old darkeys, clad in ancient dress-suits, with cotton gloves, and tall bell hats, always made their appearance with large 'Gampish' umbrellas—as I conjecture an insignia of respectability. Somehow or other the ladies of the colored persuasion manage to get hoops, although bonnets and other fashionable frivolities are out of their reach.

"One of the females represented in the picture had a *nearly* white child, a girl; and, young and old, all seemed highly delighted at getting into our lines. Let us hope they may fare better than the thousands who found a refuge from the institution in Alexandria last year; the poor creatures died there as though a plague had smitten them."

Waud worked up his sketch from this photograph, probably made in his presence by David B. Woodbury on January 1, 1863. (See page 41)

PLATE 49 Marriage at the Camp of the 7th New Jersey Volunteers, March 1863. (Eng HW April 4, 1863)

INSCRIBED: "Marriage at the camp of the 7th N.J.V. Army of the Potomac."

Waud was quite taken with the marriage in camp of Miss Lammond and Captain De Hart. He wrote in *Harper's*: "An event to destroy the monotony of life in one of Hooker's old regiments. The camp was very prettily decorated, and being very trimly arranged among the pines, was just the camp a visitor would like to see. A little before noon the guests began to arrive in considerable numbers. Among them were Generals Hooker, Sickles, Carr, Mott, Hobart Ward, Revere, Bartlett, Birney, Berry, Colonel Dickinson and other aids to General Hooker; Colonels Burling, Farnham, Egan, etc. Colonel Francine and Lieutenant-Colonel Price, of the Seventh, with the rest of the officers of that regiment, proceeded to make all welcome, and then the ceremony commenced. In a hollow square formed by the troops a canopy was erected, with an altar of drums, officers grouped on each side of this. On General Hooker's arrival the band played Hail to the Chief, and on the approach of the bridal party the Wedding March. It was rather cold, windy, and threatened snow, altogether tending to produce a slight pink tinge on the noses present; but the ladies bore it with courage, and looked, to the unaccustomed eyes of the soldiers, like real angels in their light clothing. To add to the dramatic force of the scene, the rest of the brigade and other troops were drawn up in line of battle not more than a mile away to repel an expected attack from Fredericksburg. Few persons are wedded under more romantic circumstances than Nellie Lammond and Captain De Hart. He could not get leave of absence, so she came down like a brave girl, and married him in camp. After the wedding was a dinner, a ball, fire-works, etc; and on the whole it eclipsed entirely an opera at the Academy of Music in dramatic effect and reality."

PLATE 50 Review of the Cavalry of the
Army of the Potomac, April 9, 1863.
(Eng HW May 2, 1863)

INSCRIBED: "Review by the President of the Cavalry of the Army of the Potomac. General Buford's division of regulars passing by the general gallopping at the head of the column."

The review was attended by President and Mrs. Lincoln. A New York *Herald* correspondent wrote of the event: "Every thing was in the finest style, and our Chief Magistrate could not but have felt a thrill of pride as he looked over the sea of bayonets, the blue coats, and the determined faces."

RIGHT: This enlargement of the cavalry musicians in Plate 50 illustrates Waud's unique ability to portray meticulous detail. Note the tiny rendering of troops on the distant hill.

The enlargement of Waud's portrait of President Lincoln is of special interest as the artist had seen and sketched Lincoln in person on a number of occasions during the war. (Plates 5, 14)

130

OPPOSITE:

PLATE 51 The President at the Review of the Army of the Potomac, April 9, 1863. (Eng HW May 2, 1863)

This mutilated drawing from which General Hooker's portrait has been removed, was published under the title, "The President, General Hooker, and Their Staffs at a Review in the Army of the Potomac." The lady on horseback is not identified.

PLATE 52 The Battle of Chancellorsville, May 1, 1863. (Eng HW May 23, 1863)

INSCRIBED: "Scene at Chancellorsville during the battle May 1st 1863"

Waud wrote: "After the attack upon Meade the enemy continued the battle by a vigorous effort to storm our position on the cross-roads at Chancellor's. This was a magnificent scene. The house occupies the right of the picture; about it the orderlies, servants, and pack-mules belonging to headquarters were grouped—General Hooker and his staff, with Captain Starr's company of Lancers, forming a brilliant part at the side of the house. Slocum's line of battle is seen formed in front, supporting the batteries in position about the burned chimney, which was surrounded by cherry-trees in blossom. In front are the lines of men moving up to take part in the struggle, which for a short time was violently contested at this point."

PLATE 53 Couch's Corps Covering the Retreat of the Eleventh Corps, May 2, 1863. (Eng HW May 23, 1863)

INSCRIBED: "Couch's corps. forming line of battle in the fields at Chancellorsville to cover the retreat of the Eleventh Corps, disgracefully running away."

Writing in *Harper's,* Waud described the retreat: "The German troops . . . were not equal to the occasion. Some of them fought well, but the majority fled in panic without firing a shot, throwing into confusion those troops that were preparing to resist the enemy's advance. In the midst of the skedaddle a noble buck and two does left the woods and fled through the fugitives."

PLATE 54 The Death of General Reynolds at Gettysburg, July 1, 1863.

INSCRIBED: "Death of Reynolds Gettysburg."

In a sketch probably drawn from eyewitness reports, Waud depicts the moment when General John F. Reynolds, one of Meade's best corps commanders, was struck by a sharpshooter's bullet during the fighting at Gettysburg on July 1.

Lieutenant Frank Haskell was on the field during the first day's battle and remembered: "At about five o'clock P.M., as we were riding along at the head of the column, we met an ambulance, accompanied by two or three mounted staff officers—we knew them to be staff officers of Gen. Reynolds—their faces told plainly enough what load this vehicle carried—it was the dead body of Gen. Reynolds. Very early in the action, while seeing personally to the formation of his lines under fire, he was shot through the head by a musket or rifle bullet, and killed almost instantly. His death at this time affected us much, for he was one of the *soldier* Generals of the army, a man whose soul was in his country's work, which he did with a soldier's high honor and fidelity." (*The Battle of Gettysburg* by Frank Haskell)

And Major General Henry J. Hunt wrote: "No man died on that field with more glory than he, yet many died, and there was much glory."

PLATE 55 General Warren at the Signal Station on Little Round Top, July 2, 1863.

INSCRIBED: "Gen'l Warren on Hill Top. Gettysburg."

It was General Gouverneur K. Warren whose cognizance of the strategic importance of Little Round Top saved this position from falling to advancing Confederate forces during the fighting of July 2 at Gettysburg.

PLATE 56 General Warren at the Signal Station on Little Round Top, July 2, 1863.

This engraving, redrawn by Waud from his original on-the-spot sketch (Plate 55), appeared in *Battles and Leaders* (vol. III). While directing operations on Little Round Top, Warren was wounded in the neck by a sharpshooter's bullet. A statue of General Warren, closely resembling Waud's drawing, now stands on this site on the Gettysburg battlefield.

PLATE 57 Entrenched Guns of Stevens' Battery at Gettysburg, July 2, 1863. (Eng HW August 8, 1863)

INSCRIBED: "Entrenched guns Stevens battery Gettysburg on left." "Ground over which Louisiana Tigers charged" INSCRIBED UPPER RIGHT: "appearance of Cemetery Hill previous to Pickett's charge."

In the middle background is the Cemetery Gate House on Cemetery Hill, focal point of the Confederate assault on the evening of July 2. Lieutenant G. T. Stevens' 5th Maine battery enfiladed Early's division in that attack. General Henry J. Hunt, Chief of Artillery, Army of the Potomac, writing in *Battles and Leaders* (vol. III), applauded the work of this battery: ". . . Wiedrich's Eleventh Corps and Ricketts's reserve batteries near the brow of the hill were overrun; but the excellent position of Stevens's 12-pounders at the head of the ravine, which enabled him to sweep it, . . . caused the attack to miscarry."

PLATE 58 Attack of the Louisiana Tigers at Gettysburg, July 2, 1863. (Eng HW August 8, 1863)

INSCRIBED: "Attack of the Louisiana Tigers on a battery of the 11th Corps." INSCRIBED ON BACK: "The sketch represents it as too dark—Gettysburg—July 1–3–63–."

The attack by the Confederates on Cemetery Hill pictured here was described by General Richard S. Ewell: ". . . General Early, who held the center of my corps, moved Hays' and Hoke's brigades forward against the Cemetery Hill. Charging over a hill into a ravine, they broke a line of the enemy's infantry posted behind a stone wall and advanced up the steep face of another hill, over two lines of breastworks. These brigades captured several batteries of artillery and held them until, finding that— heavy masses of the enemy were advancing against their front and flank, they reluctantly fell back, bringing away seventy-five to one hundred prisoners and four stand of captured colors." (*The Confederate Soldier in the Civil War*, 1895)

PLATE 59 Attack of the Louisiana Tigers at Gettysburg. July 2, 1863.

Engraving from *Harper's Weekly*, August 8, 1863.

This woodcut, which appeared in *Harper's*, faithfully followed Waud's original sketch (Plate 58). The dissecting lines drawn on the original drawing were done by the engraver as an aid in copying the sketch on wood blocks preparatory to engraving the picture for reproduction.

PLATE 60 Pickett's Charge at Gettysburg, July 3, 1863.
 (Eng HW August 8, 1863)

INSCRIBED: "Battle of Gettysburg. Longstreets attack upon the left center. Blue ridge in distance."

Unfortunately, Waud left no written impressions of the Battle of Gettysburg; his usual descriptive notes accompanying his drawings are totally absent from the issues of *Harper's* reporting on Gettysburg.

Brevet Lieutenant Colonel Edmund Rice, writing in *Battles and Leaders*, probably best describes this scene depicted by Waud: ". . . This was Pickett's advance, which carried a front of five hundred yards or more. . . . I had an excellent view of the advancing lines, and could see the entire formation as they swept across the Emmitsburg road, carrying with them their chain of skirmishers. They pushed on toward the crest [Cemetery Ridge], and merged into one crowding, rushing line, many ranks deep. As they crossed the road, Webb's infantry . . . commenced an irregular, hesitating fire, gradually increasing to a rapid file firing, while the shrapnel and canister from the batteries tore gaps through those splendid Virginia battalions. . . .

"By an undulation of the surface of the ground to the left of the trees, the rapid advance of the dense line of Confederates was for a moment lost to view; an instant after they seemed to rise out of the earth, and so near that the expression on their faces was distinctly seen. Now our men knew that the time had come, and could wait no longer. Aiming low, they opened a deadly concentrated discharge upon the moving mass in their front. Nothing human could stand it. Staggered by the storm of lead, the charging line hesitated, answered with some wild firing which soon increased to a crashing roll of musketry, running down the whole length of their front, and then all that portion of Pickett's division . . . appeared to melt and drift away in the powder-smoke of both sides."

139

PLATE 61 First Maine Cavalry Skirmishers, August 1863. (Eng HW September 5, 1863)

INSCRIBED: "1st Maine Cavalry Skirmishing."

These dismounted cavalrymen are shown in the act of loading and firing their breech-loading Sharps carbines on the skirmish line. On the rise in the background, minutely drawn, is an artillery battery in action.

PLATE 62 Punishment for Gamblers in the Army, October (?) 1863. (Eng HW November 7, 1863)

INSCRIBED: "General Patricks punishment of Gamblers."

Harper's wrote: "How General Patrick deals with gambling we discover from the picture above. Mr. Waud writes: 'Some inveterate players, belonging to the Ninety-third New York, were provided with a table, dice, and a tin cup for the dice-box, and, under charge of a guard, were kept at their favorite amusement all day, playing for beans, with boards slung on their shoulders with the word GAMBLER written on them. They did not seem to enjoy it, an attempt to make the most of their time and play for greenbacks being nipped in the bud. Dinner was also denied them, on the plea that gamblers have no time for meals. Much harm, no doubt, results from gambling; but it is useless to punish the men while it is so prevalent a vice with the officers.' "

Harper's added superfluously: "Gambling has always been more or less prevalent in armies."

PLATE 63 Punishment for Drunken Soldiers, October (?) 1863.

INSCRIBED: "Drunken soldiers tied up for fighting and other unruly conduct."

This drawing is a graphic example of the harsh punishment meted out to the Civil War soldier. Two men have bayonets bound across their mouths.

142

PLATE 64 Captain Sleeper's 10th Massachusetts Battery at Kelly's Ford, November 7, 1863. (Eng HW December 5, 1863)

INSCRIBED: "Fight at Kellys ford—Sleepers battery 10 Mass in foreground." (General Carr and staff are identified at the left.)

Waud reported on this action: "While General Sedgwick, with the right wing of the army, was advancing upon Rappahannock Station, General French, with the command of three corps, moved for a crossing at Kellysville. Here he found the ford protected by some rifle-pits upon the opposite bank, and beyond by other field-works, for guns as well as men. Upon these our guns opened with telling effect—Randolph's battery giving them shell, canister, and case in front, while Sleeper's [Capt. Jacob Henry Sleeper] battery enfiladed them from a height to the left, near Mount Holly Church—General French's head-quarters. . . . After a short action the accuracy of our fire caused the rebels to take to the woods in confusion, leaving a number of men in the rifle-pits. At these, wading middle-deep through the cold river, General Hobart Ward directed one of his regiments to charge. Once on the opposite shore, the advance dashed up a low ridge of earth which formed the defense, and the garrison was captured. . . .

"The more extended picture [illustrated here] shows the same thing from another point—the houses, mill, etc., called Kellysville, beyond the ford; still further, the rifle-pits and pine woods, where the enemy found refuge. The houses in Kellysville, also Brown's, on the left, were riddled. Sleeper's battery, on the authority of some prisoners, is said to have taken off the legs of some of the rebel staff officers. Their horses were killed, and left upon the ground, to show the severity of the fire. A whole brigade ran away, leaving their muskets stacked, and then came out in small squads to get them again."

PLATE 65 View of Culpeper, Virginia, September 1863. (Eng HW October 3, 1863)

INSCRIBED: "Culpepper from the Nor-West."

Slowly pursuing Lee into Virginia, Meade, late in 1863, made his headquarters at Culpeper, a small town at the foot of the Blue Ridge which had been alternately occupied by both armies and was by this time virtually deserted.

PLATE 66 Dragging Artillery through the Mud at Night, February 1864. (Eng HW March 19, 1864)

INSCRIBED: "Dragging up the guns on the recent reconnoisance in force (night)"

PLATE 67 Burning of the Mill at Stanardsville, March 1, 1864. (Eng HW March 26, 1864)

INSCRIBED: "Mill in Stannardsville."

This was an incident of Custer's raid across the Rapidan described in detail by Waud on pages 43–47.

PLATE 68 Grant's Telegram of the News of the Crossing of the Rapidan, May 4, 1864.

An example of Waud's infrequent use of photographs in composing some of his sketches appears in this drawing of General Ulysses S. Grant writing a telegram on May 4, 1864, at the beginning of the Wilderness campaign to inform General Halleck that the Union army had crossed the Rapidan. The officer pictured to the left of Grant is General Ely S. Parker, a full-blooded Indian. In making this drawing at a later date, possibly during the Petersburg campaign, Waud utilized the figure of the officer standing to the right in the above photograph of General Orlando B. Willcox (seated) and staff. (Photo from the Collection of the Library of Congress)

PLATE 69 Wadsworth's Division in Action in the Wilderness, May 6, 1864. (Eng HW June 4, 1864)

INSCRIBED: "Genl. Wadsworths division in action in the Wilderness, near the spot where the General was killed."

Harper's reported: "We give you a striking sketch of the engagement of General WADSWORTH'S Division of the Army of the Potomac in the Wilderness near Chancellorsville, showing where the lamented WADSWORTH fell at the head of his command. The sketch gives a good idea of the almost impenetrable nature of the Wilderness, and of the disadvantages under which our soldiers fought."

PLATE 70 Wounded Soldiers Escaping from the Burning Woods, May 6, 1864. (Eng HW June 4, 1864)

INSCRIBED: "Wounded escaping from the burning woods of the Wilderness"

Waud wrote in *Harper's:* "The fires in the woods, caused by the explosion of shells, and the fires made for cooking, spreading around, caused some terrible suffering. It is not supposed that many lives were lost in this horrible manner: but there were some poor fellows, whose wounds disabled them, who perished in that dreadful flame. Some were carried off by the ambulance corps, others in blankets suspended to four muskets, and more by the aid of sticks, muskets, or even by crawling. The fire advanced on all sides through the tall grass, and, taking the dry pines, raged up to their tops."

PLATE 71 The Fight for the Salient at Spotsylvania, May 12, 1864. (Eng HW June 11, 1864)

INSCRIBED: "The toughest fight yet—The fight for the Salient."

A New York *Times* correspondent reported: "So terrific was the death-grapple . . . that at different times of the day the rebel colors were planted on the one side of the works and ours on the other, the men fighting across the parapet. Nothing during the war has equaled the savage desperation of this struggle, which was continued for fourteen hours."

PLATE 72 General Warren Rallying the Marylanders, May 12, 1864.
 (Eng HW June 11, 1864)

INSCRIBED: "Genl Warren rallying the Marylanders." A "white horse" and "ragged flag" are also specified.

This incident during the Battle of Spotsylvania was described by the artist: "He [Warren] seized the colors of a regiment from the hands of a retiring Sergeant and, carrying them himself, led the regiment back to its place in the line of battle in spite of a storm of shot and shell."

Waud's careful attention to portraiture in his sketches is illustrated in this enlargement of the drawing of his friend, General Warren.

150

PLATE 73 General Barlow's Charge at Cold Harbor, June 3, 1864. (Eng HW June 25, 1864)

INSCRIBED: "7th N. Y. Heavy Arty in Barlows charge. nr Cold Harbor Friday June 3rd 1864."

Waud wrote: "This sketch represents a portion of the line at the time when they had captured the first line of rifle-pits, and were about to advance upon the second. The regiment is the New York Seventh Heavy Artillery. Some of the men seen over the embankment endeavoring to turn the enemy's captured guns upon them, under the direction of Lieutenant-Colonel MORRIS, Colonel PORTER having been killed in the charge. In the fore-ground the prisoners are seen rapidly divesting themselves of their accoutrements, the first thing being always the disarming of the captured. Near them some soldiers are moving the Colonel in a blanket; and above a captured flag, with the Virginia State arms emblazoned upon it, is carried in by one of our soldiers."

PLATE 74 A Panoramic View of the Situation around Petersburg (William Waud), June 1864. (Eng HW June 23, 1864)

Harper's reported: "The large double-page cut is a panoramic view of the country as well as the military situation around Petersburg. The view is thus disclosed from WEITZEL's Look-out and Signal Tower, at Bermuda Hundred, looking southward—including in that direction about ten miles, thus taking in Petersburg, on the extreme right. From Petersburg the Appomattox runs from right to left, emptying into the James. City Point is not included in the view; but the pontoon-bridge is disclosed by which the army communicates with Bermuda Hundred."

PLATE 75 Pontoon Bridge on the Appomattox at Point of Rocks, June 1864. (Eng HW June 23, 1864)

INSCRIBED: "Ponton Bridge on the Appomattox below Petersburg—Point of Rocks. Butler's Headquarters"

Harper's described the picture: "Where Point of Rocks juts out into the river is General BUTLER'S head-quarters . . . at the dock is the *Greyhound*, the flag-ship of that officer, and the *Sylvan Shore*."

Note the precise detail work on the vessels. This drawing was erroneously credited to William Waud when it appeared in *Harper's*.

154

PLATE 76 Captain Ashby's New York Artillery in Action at the Siege of Petersburg, June–July 1864. (Eng HW July 30, 1864)

INSCRIBED: "Right Section. Comp. E 3rd N. Y. Arty, Capt Ashby 20 pounder parrott."

PLATE 77 Battery of Mortars and Light Twelves before Petersburg, July 1864. (Eng HW August 6, 1864)

INSCRIBED: "Battery of Mortars and light twelves. Lt. Jackson 1st Connecticut heavy Arty 18th corps."

Waud described the scene: "The drawing of a battery of mortars and light twelves represents a salient on the line of the Eighteenth Corps, which is a source of great annoyance to the rebels. Lieutenant JACKSON constantly drops his shells among their men, as he jocosely remarks, 'to prevent the Johnnies sleeping too sound.' They do not fail to return the compliment with shells and bullets of sharp-shooters. The mortars are fired without the gunner seeing the spot he aims at. With the aid of the frame-work round the piece, marked in divers places with the positions of points upon the rebel line, and a piece of string leading from the bayonet stuck in the sandbags on the parapet down to the frame, he directs the fire of the piece; and as the shell is visible as it leaves the smoke till it falls into the doomed spot, it is very interesting to watch the practice."

Note the furniture under the shelters at the left, probably removed from the house in the background. A Confederate shell is seen exploding at the far right.

PLATE 78 Aiming a Mortar in Jackson's Connecticut Battery, July 1864.

This sketch is an elaboration of a part of the scene in Plate 77.

157

PLATE 79 Siege of Petersburg, June–July 1864.

INSCRIBED: "On the front line of operations 18th Corps Protecting the gunners by mantelets—"

The drawing illustrates clearly how the gunners were shielded by mantelets made from woven ropes.

OPPOSITE:

PLATE 80 Sharpshooters in Front of Petersburg, July 1864. (Eng HW August 6, 1864)

INSCRIBED: "Sharpshooters 18th Corps."

Attached note by Waud: "Sharpshooters of the 18th Corps Front. On some portions of the lines picket firing was soon discontinued. Genl. Warren considered it unnecessary to the safety of the 5th Corps front, and put a stop to it. The enemy did likewise. But where the practice was in vogue it was very dangerous to be exposed. A common plan of protection was that shown in the sketch, by a wooden tube widening outwards like a miniature embrasure buried in the crest of the rifle pit and protected by sandbags."

Sharpshooters 10th C...

PLATE 81 Wilson's Raid against Lee's Lines of Communication, June 22–July 1, 1864. (Eng HW July 30, 1864)

INSCRIBED: "Destruction of Genl. Lees lines of communication in Virginia by Genl Wilson" (Major General James H. Wilson)

Harper's gave this account of the raid: "GENERAL WILSON'S raid . . . dealt a serious blow against LEE'S lines of communications with the South. This illustration affords the reader a vivid, and at the same time a correct, impression of the manner in which an extensive cavalry raid is carried. So far from being an irregular proceeding, a great raid is now as well organized as any other movement

of the army; each man has his work to do, and one stage of operations succeeds another as regularly as the evolutions on a parade-ground. WILSON'S raid resulted in the destruction of sixty miles of railroad, a destruction in which the Danville and the Southside road shared about equally. General WILSON reported that it would take the rebels forty days, even if they had the material at hand to repair the loss. The expedition had some difficulty in returning; but it succeeded finally in eluding the enemy, getting back to our lines with a loss of twelve cannon and between 750 and 1000 men."

PLATE 82 Carrying Powder to the Mine at Petersburg, July 1864.

INSCRIBED: "Carrying the powder down the covered way to the mine under fire."

The Petersburg mine, excavated by the 48th Pennsylvania Regiment under the command of Colonel Henry Pleasants, tunneled under the Confederate works and was exploded on the morning of July 30, 1864.

PLATE 83 The Explosion of the Mine before Petersburg, July 30, 1864. (Eng HW August 20, 1864)

Attached note by Waud: "Explosion of the mine under the Confederate works at Petersburg—July 30, 1864. The spires in the distance mark the location of the city; along the crest in front of them are the defensive works, it was an angle of these that was blown up with its guns & defenders. The explosion was the signal for the simultaneous opening of the artillery and musketry of the Union lines. The pickets are seen running in from their pits and shelters on the front, to the outer line of attack. In the middle distance are the magnificent 8 & 10 inch mortar batteries, built and commanded by Col. Abbott. Nearer is a line of abandoned rifle pits—and in the foreground is the covered way, a sunken road for communication with the siege works and the conveyance of supplies and ammunition. The Chief Engineer of the A. of P. is standing upon the embankment watching the progress throw [*sic*] a field glass."

"Our artist," wrote *Harper's*, "furnished the following graphic description: 'The picture is from a sketch made upon the Fifth Corps line at the time when the cannonade opened along the entire front, just before sunrise. . . . Our lines can be traced by the smoke of the artillery fire, representing a portion of the Fifth and Ninth Corps. In the fore-ground is a battery of 8-inch mortars and some light batteries of the Fifth Corps, of which Colonel WAINWRIGHT is chief of artillery. . . .

"'Coming upon this line soon after daylight of the 30th ult., a calm and clear morning, the rebels were plainly visible sitting about, and strolling upon and in front of their parapets, looking at the progress we had made, and enjoying the cool air, apparently unsuspicious. On our side no unusual number of men was visible, the works and covered ways giving ample concealment. Nevertheless many anxious eyes were directed to the point of the expected explosion, speculating upon the cause of its delay. The fuse had failed, and it was but a short time before sunrise that the mine was sprung. With a muffled roar it came,

Before Petersburg — at Sunrise July 30th 1864

and as from the eruption of a volcano—which it much resembled—upward shot masses of earth, momently illuminated from beneath by a lurid flare. For a few seconds huge blocks of earth and other *debris*, mingled with dust, was seen in a column perhaps 150 feet in height, and then the heavy volume of smoke, which spread out in billowy waves on every side, enveloped all, like a shadowy pall for the two hundred souls thus rushed into eternity. As if for breath there was a short pause, the rebels regarding the giant apparition as though spell-bound, and then one hundred and fifty guns opened in one grand volley upon the rebel works. . . .'"

OPPOSITE:
Note the precise needle-sharp delineation of the "magnificent" mortar battery in this enlargement of the middle foreground of the accompanying sketch.

Scene of the Explosion, Saturday July 30

PLATE. 84 The Advance into the Crater before Petersburg, July 30, 1864. (Eng HW August 27, 1864)

INSCRIBED: "Scene of the Explosion, Saturday July 30th."

Harper's reported: "The illustration . . . represents the charge which followed the explosion in front of Petersburg, July 30. This sketch gives also a more detailed outline of the scene of the exploded mine. The heights shown in the picture are those of Cemetery Ridge, and were the points aimed at by our troops. In the fore-ground is the crater formed in the rebel works by the explosion. Here it was that our soldiers were massed for further efforts, while in the mean time troops are hurrying up for support. This was the ground also of the flag of truce, and was literally covered with the fallen."

Waud's own account of the Union disaster at the Battle of the Crater appeared in *Harper's*, August 20: "The storming columns could be seen springing forward to the doomed work; but the rapid cannonade soon hid that portion of the line in smoke, though the savage discharges of musketry showed plainly the enemy did not propose giving up without a struggle. . . .

"On the parapets of the works they had erected, the engineers and their chief, Major DUANE, carefully watched the contest. The hours sped along, and yet no success; when the smoke lifted the attacking column of the Ninth Corps became visible in the crater of the explosion, huddled in masses, but with their colors planted upon the ruins, and returning the enemy's fire with musketry and the rebel cannon, which they had turned upon its former owners. It was easy to see that the ground was covered with the dead and wounded. Many ran to the rear, not a few being shot down before reaching cover. Others could be seen running up the gentle slope toward Petersburg, voluntary prisoners. The rebels in their turn charged our men, yelling as they came up. In this attack they were successful, driving some back and capturing others, in spite of the staggering volleys they received; and it then became evident the attack had failed, with more men lost than would have been if they had pushed on and taken the crest of the hill."

Waud's drawing shows the 4th (Colored) Division going into action. The exaggerated feet on the soldier at the far left are a curiosity; Waud may have meant to indicate to the engraver the pattern of nails in the sole of the shoe.

PLATE 85 Confederate Cattle Raid, September 16, 1864. (Eng HW October 8, 1864)

INSCRIBED: "Cattle Raid."

Attached note by Waud: "Confederate cattle raid Sept 16th 1864. Genl Wade Hampden suddenly appeared at Coggins point in the rear of the army, on the James river, and carried off the entire beef supply, about 2500 head of cattle. The rebel soldiers were much inclined to joke with the pickets on the loss of their meat rations. The union men, on the other hand thanked them heartily for removing the tough remnants of herds that had been driven behind the army all summer and which were at once replaced by a fresh stock much fitter for the table."

Lincoln called Hampton's beef raid "the slickest piece of cattle stealing I ever heard of."

PLATE 86 Sheridan's Wagon Trains in the Shenandoah Valley, October 1864. (Eng HW November 12, 1864)

INSCRIBED: "Sheridan's Wagon Trains in the Valley. Early Morning—Mist and Smoke."

PLATE 87 Custer's Division Retiring from Mount Jackson in the Shenandoah Valley, October 7, 1864.

INSCRIBED: "The 3rd Custer div. on the 7th of Oct retiring and burning the forage Somewhere near Mt. Jackson."

General Wesley Merritt, writing in *Battles and Leaders* (vol. IV), provided an apt description of Sheridan's Valley campaign and this sketch by Waud: "When the army commenced its return march, the cavalry was deployed across the Valley, burning, destroying, or taking away everything of value, to the enemy. It was a severe measure, . . . but it was necessary as a measure of war. . . . The Valley from Staunton to Winchester was completely devastated, and the armies thereafter occupying that country had to look elsewhere for their supplies."

PLATE 88 Custer's Division Retiring from Mount Jackson, October 7, 1864.

The rough sketch (Plate 87) was redrawn by Waud for *Battles and Leaders* and was entitled "The Rear-Guard—General Custer's Division Retiring from Mount Jackson, October 7, 1864. From a War-time Sketch."

This is an interesting example of the development of the sketch done in the field during the war to the finished drawing and engraving. Note the quality of this engraving, done in the 1880s, as compared with the cruder woodcuts of the Civil War period.

PLATE 89 The Shenandoah Valley from Maryland Heights, 1864 (?).

PLATE 90 Sheridan's Army in the Shenandoah Valley, October 1864. (Eng HW October 22, 1864)

INSCRIBED: "Sheridan's Army following Early up the Valley of the Shenandoah."

Harper's wrote: ". . . we give an illustration of General SHERIDAN leading his gallant army in pursuit of an already routed and dispirited enemy. The General as he rides along the line is greeted with hearty cheers."

OPPOSITE:

PLATE 92 Signaling by Torches across the James River (William Waud), October 1864. (Eng HW November 12, 1864)

INSCRIBED ON BACK: "Night Signalling—Signal Corps."

Of this sketch *Harper's* noted: "It is at these quarters that the signaling is observed by means of a telescope. The messages from the high signal tower on the other side of the river are read by the sergeant or officer at the telescope, and the reply is signaled by the man with the torch."

PLATE 91 Hospital Attendants Collecting the Wounded at Night (William Waud), October 1864. (Eng HW October 29, 1864)

INSCRIBED ON BACK: "Hospital attendants collecting the wounded after the engagement—Within our lines near Hatchers run."

PLATE 93 Custer Presenting Captured Confederate Flags in Washington, October 23, 1864. (Eng HW November 12, 1864)

INSCRIBED: "Genl Custer presenting the flags captured in the last battle in the Valley." INSCRIBED ABOVE: "Flag when perfect"—"Most of them (flags) very ragged"—"Custer very fashionable Men exceedingly rough"

Harper's reported: "We give in the subjoined illustration a representation of the highly interesting ceremony in which General CUSTER officiated, on Sunday, October 23—namely, that of presenting to the Secretary of War the Battle-Flags captured from the Rebels in the Battle of Cedar Creek . . . During the presentation it was announced that General CUSTER had been appointed Major-General, and this fact occasioned great enthusiasm among the large crowd assembled to witness the ceremony. One of the colors captured was the head-quarters flag of the late rebel General RAMSEUR, bearing

the inscription, 'On to Victory! Presented by Mr. W. T. Sutherlin.' A large number of the colors were taken by CUSTER's Division. General RAMSEUR was a class-mate of General CUSTER'S at West Point, and as the former was dying the two reviewed together the reminiscences of their cadet life."

PLATE 94 Porter's Fleet Leaving Chesapeake Bay for Fort Fisher, December 13, 1864. (Eng HW December 31, 1864)

INSCRIBED: "For Ft. Fisher direct. The Expedition leaving the Chesapeake."

The December assault on Fort Fisher, North Carolina, by combined sea-and-land forces under Admiral David D. Porter and General Benjamin F. Butler was repulsed by the Confederate garrison. The following month (January 1865) the fort was finally taken and Wilmington (North Carolina) fell to Federal forces.

PLATE 95 Sherman Reviewing His Army in Savannah (William Waud), January 1865. (Eng HW February 11, 1865)

INSCRIBED AT TOP: "Bay Street"—"The Customs House" INSCRIBED BELOW: "put troops arms at shoulder instead of right shoulder shift as in sketch." INSCRIBED ON BACK: "Gen Sherman reviewing his Army in Savannah before starting on his new campaign—among the mounted officers behind Major General Sherman are Gen Williams, Logan, Slocum, Geary, Baird, Woods, Smith Etc."

PLATE 96 Sheridan's Charge on Pickett's Division at Five Forks, April 1, 1865.

INSCRIBED: "When Pickets div surrendered it grouped around this tree." INSCRIBED (*for engraver*): "There should be wider interval between the two charging lines, and perhaps a little more broken—"

The Battle of Five Forks, fought seventeen miles southwest of Petersburg on April 1, 1865, culminated in the defeat of Pickett's division by Federal infantry and cavalry. It was here that Waud's friend General Warren was relieved of his command of the Fifth Corps by General Sheridan. Years later (1882) a court of inquiry exonerated Warren of culpability. (See Warren's correspondence with Waud in Appendix.)

175

PLATE 97 Assault on Fort Gregg, April 2, 1865.

INSCRIBED: "Assault of the 24th Corps charging a fort to the left. Briscoes Brigade."

The capture of Forts Gregg and Whitworth, Confederate strong points in the Petersburg defenses, forced Lee, after a ten-month siege, to evacuate that city on the night of April 2–3, 1865.

PLATE 99 The Last of General Lee's Headquarters, April 1865.

INSCRIBED: "The last of Genl. Lees Headquarters. Petersburg—after the battle."

Waud accompanied the Federal troops into Petersburg following the evacuation by Lee's army. General Horace Porter described Grant's entry into the city on the morning of April 3: "About 9 A.M. the general rode into Petersburg. Many of the citizens, panic-stricken, had escaped with the [Confederate] army. Most of the whites who remained staid indoors, a few groups of negroes gave cheers, but the scene generally was one of complete desertion." (*Battles and Leaders,* vol. IV)

OPPOSITE:

PLATE 98 Bridge on the Appomattox River, Petersburg, April 1865.

INSCRIBED: "Bridge on the Appomattox. Train of Cars and workshops burned by the rebels in evacuating Petersburg."

PLATE 100 The Last of Ewell's Corps, April 6, 1865.

INSCRIBED: "The last of Ewells Corps April 6" INSCRIBED ON BACK: "This was quite an effective incident in its way the soldiers silhouetted against the western sky—with their muskets thrown butt upwards in token of surrender, as our troops closed in—beyond a wagon train, which was captured, and burning debris probably other wagons in the gathering gloom—"

178

PLATE 102 Custer Receiving the Flag of Truce, April 9, 1865.

INSCRIBED: "Custer receiving the flag of truce—Appomattox—1865"

The sketch depicts the moment that Confederate Captain R. M. Sims carried a white flag to General George A. Custer at Appomattox. The "flag" was actually a white towel with a red border.

OPPOSITE:

PLATE 101 The Capture of Ewell's Corps, April 6, 1865.

This pen-and-ink drawing of the surrender of Ewell's Corps was redrawn by Waud for *Battles and Leaders* (vol. IV). The artist substituted an army forge for the caisson that appears in the original sketch.

Genl Lee leaving the McLean [house?]

OPPOSITE:

PLATE 103 General Lee Leaving the McLean House after the Surrender, April 9, 1865.

INSCRIBED: "Genl Lee leaving the McLean house after the Surrender. Orderlies holding horses all about."

This final act of the war in Virginia was described by General Horace Porter in *Battles and Leaders* (vol. IV): "At a little before 4 o'clock General Lee shook hands with General Grant, bowed to the other officers, and with Colonel Marshall left the room. One after another we followed, and passed out to the porch. Lee signaled to his orderly to bring up his horse, and while the animal was being bridled the general stood on the lowest step and gazed sadly in the direction of the valley beyond where his army lay—now an army of prisoners. . . . All appreciated the sadness that overwhelmed him, and he had the personal sympathy of every one who beheld him at this supreme moment of trial. The approach of his horse seemed to recall him from his reverie, and he at once mounted. General Grant now stepped down from the porch, and, moving toward him, saluted him by raising his hat. He was followed in this act of courtesy by all our officers present; Lee raised his hat respectfully, and rode off to break the sad news to the brave fellows whom he had so long commanded."

PLATES 104 and 105

These drawings represent the development of the original sketch to its final rendering. The first, opposite, was made undoubtedly at the time of the surrender; the second, top right, was a more finished sketch based upon the original; finally, at right, is the completed pen sketch made by Waud in the 1880s for the Century series, *Battles and Leaders of the Civil War* (vol. IV).

PLATE 106 Libby Prison, Richmond, Virginia, April 1865

INSCRIBED: "Libby again, Rebel Soldiers waiting for accommodations in that Hotel."
INSCRIBED UPPER LEFT: "lower half whitewashed."

This converted warehouse of Libby & Sons, ship chandlers, situated on the James River in Richmond, was a notorious Confederate prison for Union officers during the war.

PLATE 108 Black Soldiers Mustered Out at Little Rock, Arkansas, April 1866. (Eng HW May 19, 1866)

Waud described the event: "Standing before the office of Colonel Page Quarter-master, the scene which I have sketched was very interesting, occasioned by the meeting of 'mustered out' colored troops with their wives and friends at Little Rock, Arkansas. Just in from Duvall's Bluff, where they had been stationed, their landing created a furor among the resident colored females, many of whom, I am afraid, were disappointed in not meeting those whom they expected. Others rushed into the arms of their husbands with an outburst of uncontrollable affection. Ceremonious introductions between comrades and wives displayed a degree of politeness quite commendatory to all the parties concerned. Children ran about with bundles of blankets or knapsacks for their papas, or begged the privilege of carrying a gun for some sable warrior, and all were in high good humor, with the exception of those who missed the faces of their husbands or brothers."

This sketch was made by Waud during his first trip west for *Harper's* in 1866.

OPPOSITE:

PLATE 107 The Interior of Ford's Theater, April 1865.

This sketch, made from the dress circle of Ford's Theater in Washington, was a reference drawing for the engravers at *Harper's*. On it Waud has indicated the spot where John Wilkes Booth had jumped to the stage from Lincoln's box after shooting the President, indicating a leap of eleven feet, six inches. Waud also noted the colors of some of the furnishings and instructed the engraver to "correct the perspective."

List of the Plates

1 Washington Street, Boston
2 The Washington Navy Yard
3 Funeral of Colonel Vosburgh
4 General Winfield Scott and Staff
5 President Lincoln and General Scott Reviewing Troops on Pennsylvania Avenue
6 Scouting Party of Schenck's Ohio Regiment near Fairfax Court House
7 Burnside's Brigade at the First Battle of Bull Run
8 First Day's Action at Hatteras Inlet
9 Painting based on the sketch in Plate 8
10 Flag of Truce—Near Norfolk, Virginia
11 General Sickles Reconnoitering along the Potomac
12 Sutler's Cart at Bailey's Cross Roads, Virginia
13 Thanksgiving in Camp
14 Grand Reception at the White House
15 The Battle of Kernstown
16 McClellan crossing Bull Run at Blackburn's Ford
17 McClellan's Army Landing at Hampton, Virginia
18 Lieutenant Custer Wading in the Chickahominy
19 Rebels Leaving Mechanicsville
20 Battle of Hanover Court House
21 Burying the Dead and Burning the Horses at Fair Oaks
22 Confederates Capturing Disabled Guns at Gaines's Mill
23 Franklin's Corps Falling Back near Trent's House
24 Retreat from the Chickahominy (Engraving)
25 Graham's 5th Excelsior Regiment Shelled While Being Reviewed
26 U. S. Gunboats Shelling the Confederates at Battle of Malvern Hill
27 Battle of Malvern Hill
28 Skedaddler's Hall
29 Pope's Defeat at the Second Battle of Bull Run
30 The Confederate Army Crossing the Potomac by Moonlight
31 The 1st Virginia Cavalry
32 Burning of Mumma's Houses and Barns During the Battle of Antietam
33 Skirmish between the 14th Brooklyn and Confederate Cavalry at Antietam
34 Citizen Volunteers Assisting the Wounded on the Field of Antietam
35 Carrying off the Wounded after the Battle (Engraving)
36 Pleasonton's Cavalry Deployed as Skirmishers
37 Crossing the Pontoon Bridge at Berlin, Maryland
38 Stripping a Rail Fence for Firewood
39 On the Burned Railroad Bridge at Fredericksburg
40 Building a Pontoon Bridge Under Fire at Fredericksburg
41 Sumner's Grand Division Crossing the Rappahannock
42 Attack on the Rebel Works at Fredericksburg
43 Charge of Humphreys' Division at the Battle of Fredericksburg
44 Woodcut version of the sketch in Plate 43
45 Signal Telegraph Machine and Operator, Fredericksburg

46 Signal Telegraph Train Used at the Battle of Fredericksburg
47 The Mud March
48 Contrabands Coming into Camp
49 Marriage at the Camp of the 7th New Jersey Volunteers
50 Review of the Cavalry of the Army of the Potomac
51 The President at the Review of the Army of the Potomac
52 The Battle of Chancellorsville
53 Couch's Corps Covering the Retreat of the Eleventh Corps
54 The Death of General Reynolds at Gettysburg
55 General Warren at the Signal Station on Little Round Top
56 Engraving redrawn from sketch in Plate 55
57 Entrenched Guns of Stevens' Battery at Gettysburg
58 Attack of the Louisiana Tigers at Gettysburg
59 Woodcut made from the sketch in Plate 58
60 Pickett's Charge at Gettysburg
61 First Maine Cavalry Skirmishers
62 Punishment for Gamblers in the Army
63 Punishment for Drunken Soldiers
64 Captain Sleeper's 10th Massachusetts Battery at Kelly's Ford
65 View of Culpeper, Virginia
66 Dragging Artillery through the Mud at Night
67 Burning of the Mill at Stanardsville
68 Grant's Telegram of the News of the Crossing of the Rapidan
69 Wadsworth's Division in Action in the Wilderness
70 Wounded Soldiers Escaping from the Burning Woods
71 The Fight for the Salient at Spotsylvania
72 General Warren Rallying the Marylanders
73 General Barlow's Charge at Cold Harbor
74 A Panoramic View of the Situation around Petersburg (William Waud)
75 Pontoon Bridge on the Appomattox at Point of Rocks
76 Captain Ashby's New York Artillery at the Siege of Petersburg
77 Battery of Mortars and Light Twelves before Petersburg
78 Aiming a Mortar in Jackson's Connecticut Battery
79 Siege of Petersburg
80 Sharpshooters in Front of Petersburg
81 Wilson's Raid against Lee's Lines of Communication
82 Carrying Powder to the Mine at Petersburg
83 The Explosion of the Mine before Petersburg
84 The Advance into the Crater before Petersburg
85 Confederate Cattle Raid
86 Sheridan's Wagon Trains in the Shenandoah Valley
87 Custer's Division Retiring from Mount Jackson
88 Engraving made from redrawing of the sketch in Plate 87
89 The Shenandoah Valley from Maryland Heights
90 Sheridan's Army in the Shenandoah Valley
91 Hospital Attendants Collecting the Wounded at Night (William Waud)
92 Signaling by Torches across the James River (William Waud)
93 Custer Presenting Captured Confederate Flags in Washington
94 Porter's Fleet Leaving Chesapeake Bay for Fort Fisher
95 Sherman Reviewing His Army in Savannah (William Waud)
96 Sheridan's Charge on Pickett's Division at Five Forks
97 Assault on Fort Gregg
98 Bridge on the Appomattox River, Petersburg
99 The Last of General Lee's Headquarters
100 The Last of Ewell's Corps
101 Pen-and-ink version of sketch in Plate 100
102 Custer Receiving the Flag of Truce
103 General Lee Leaving the McLean House after the Surrender
104 Revision of the sketch in Plate 103
105 Plate 103 redrawn for *Battles and Leaders of the Civil War*
106 Libby Prison, Richmond, Virginia
107 Interior of Ford's Theater
108 Black Soldiers Mustered Out at Little Rock, Arkansas

Appendix

On a page of notepaper of uncertain date, found in the Malcolm F. J. Burns Collection, Waud expressed his personal opinions of the commanders of the Army of the Potomac:

> The "young Napoleon" [McClellan], as he is sneeringly called, certainly went to Washington with a magnificent egotism, a self confidence, born of his just belief in his ability and knowledge. He saw what had to be done. He was almost alone in seeing how to do it & it was a great undertaking in which he did not fail. It was not permitted to him that he should succeed. Perhaps it was as well. With men of less ability it had to be fought to a point where one of the combatants was utterly worn out and at the mercy of the conqueror thus making it possible to close the struggle in a way that made it impossible that it could ever be renewed. The principal accusation made against him as a general is that he was slow. Was it so? What did other generals do? What did his successors do that was comparable to his campaigns? Burnside quietly sat down on the Rappahannock and politely waited till Lee had made a strong natural position impregnable, attacked it and was defeated. Hooker kept his men in camp feeding and nursing them, supplying them bountifully with new clothing and then lost a battle. The enemy did not have half his numbers, but nothing is said of his inferiority. Next came Meade and Gettysburg was won partly because it was a defensive battle on our side, partly because the soldiers were inspirited by the belief that McClellan was in command of them. Not till the fight was over did they know who their commander was. From this time on Meade risked no other battle till Grant made his headquarters with the A. of P. [Army of the Potomac]. By this time the S. C. [Southern Confederacy] was in straits. It was difficult for them to raise men, still more difficult for them to [illegible] equip and feed them. They were no longer, as in McClellan's time, better armed and equally as well fed and clothed as our men. Grant [illegible] against them with 125,000 besides the reserve, May 1864. Lee's force was 52,000 raised during the campaign by an addition of 18,000, whilst Grant received reinforcements amounting to 97,000. Of these forces Lee had placed hors de combat 19,000 and Grant 117,000. McClellan never did anything so ruinous. Compare it with the Peninsula.
>
> [illegible] John G. Nicolay ignores the fact that Mr. Lincoln's feeling was that McClellan should again be commander of the Army after it was proved that his successors had failed almost criminally. Stanton was the man who stood in the way of what was certainly a correct conclusion. No one of good military training can believe it possible that such fearful sacrifice would have accompanied the success of our arms as took place in the A. of P. in 1864.

Waud's opinions are clear. He was most emphatically endorsing General George B. McClellan's leadership as superior to his sucessors', an evaluation echoed by many, if not the majority, of the fighting men in blue.

On June 29, 1880, General G. K. Warren, facing a court of inquiry concerning his supercession at the Battle of Five Forks (April 1865), wrote to Waud requesting the latter's presence at Governor's Island. Written from the Stevens House at 27 Broadway, New York City, Warren's letter follows:

To Mr. A. R. Waud Artist
No. 162 East 22nd St.*
New York, N.Y.

My dear friend

I have just learned through Genl Abbot and Dr. Clements that you have worked up the sketch of the scene of the last assault at 5 Forks as you sketched it with me a few days after—With the assault I suppose left out.

I want you to come to Governor's Island to morrow, *if you can* (if not Saturday will do) and meet me at the *Court rooms*. If your sketch is in portable shape, bring it with you. I write rather nervously, or rather, I am somewhat nervous while I write. But I do want to see you, as soon as I can. You can surely find me where I have named. Outside of the court I have special engagements and I cannot in my present position make any appointments in a business way disconnected with the court, which Judicially claims all my time.

I am at very considerable expense in maintaining myself before this court; which has ever taxed my ordinary means of living; and my relatives have assisted me. So, if my request to you causes you a loss of time and the support to yourself and family which comes from [illegible] use of your time in helping me, my relatives and myself will see you out, for any loss of time you may make in using any honest efforts in my defense such as you may choose to make.

I have sent this by my special messenger Mr. Haher to follow you for an answer such as may suit you to give and

God bless you
G. K. Warren

Swinter has deserted me.

The following day Warren sent Waud another letter in response to what was undoubtedly an affirmative reply to the previous missive. The tone of Warren's letters indicates his concern with the court of inquiry.

Mr. A. R. Waud
No. 162 E. 122nd St.
New York, N.Y.

My very dear friend

I am much pleased to receive yours of yesterday.

Don't let my request cause you to lose any time from those implacable publishers. Keep at your work if there is money in it. My personal testimony is to begin tomorrow and may take several days. After that I shall have some freedom. So if you could improve next Saturday in any way to yourself, don't come; and if the Fourth of July leaves us alive, we may meet thereafter with myself being possessed of more freedom than I now have. Swinter has always been my friend, and we will see him together sometime soon.

God bless you my dear fellow. If I had more power to help my friends I should not ask so much from God, and, reverentially, I really don't expect much from Him personally when He lets things run as they do, in his Infinite Wisdom, before which I bow.

Yours truly
G. K. Warren

* Warren erred in the address of the first letter and corrected it in the second.

Selected Bibliography

The books listed here contain illustrations by Alfred R. Waud and (or) refer to him in the text.

Hunter's Panoramic Guide from Niagara to Quebec by W. S. Hunter, Jr. Boston, 1857.
Thirty Years of Army Life on the Border by Colonel R. B. Marcy, U.S.A. New York, 1866.
Harper's Pictorial History of the Great Rebellion (2 Vols.). Chicago, 1866–1868.
Siege of Washington, D. C. . . . by Captain F. Colburn Adams. New York, 1867.
Theatrical Management in the West and South . . . by Sol Smith. New York, 1868.
Beyond the Mississippi by A. D. Richardson. Hartford, 1869.
Hannah's Triumph by Mary A. Denison. Philadelphia, 1870.
Specimen Pages and Illustrations from Appleton's Journal. New York, 1870.
Album of Wood Engravings by John Andrew. Boston, c. 1860–1870. (Including works of William Waud.)
Garnered Sheaves from the Writings of Albert D. Richardson . . . Hartford, 1871. (Including works of William Waud.)
Picturesque America (2 Vols.), edited by William Cullen Bryant. New York, 1872–1874.
The Great South by Edward King. Hartford, 1875.
A Complete Life of Gen. George A. Custer by Frederick Whittaker. New York, 1876.
Guarding the Mails . . . by P. H. Woodward. Hartford, 1876.
Pioneers in the Settlement of America . . . (2 Vols.) by William A. Crafts. Boston, 1876–1877.
Life of Winfield Scott Hancock by David X. Junkin. New York, 1880.
Bryant's Popular History of the United States (4 Vols.) by William Cullen Bryant and Sydney Howard Gay. New York, 1881.
Battles and Leaders of the Civil War (4 Vols.). The Century Company. New York, 1884–1888.
Mountain Campaigns in Georgia or War Scenes on the Western & Atlantic. 1886.
McClellan's Own Story by George B. McClellan. New York, 1887.
American Artists and Their Work (2 Vols.). Boston, 1889.
Columbus and Columbia. Philadelphia, 1892.
The Story of America, 1492–1892 by Hamilton W. Mabie and Marshal H. Bright. Philadelphia and Chicago, 1893.
Campfire and Battlefield by Rossiter Johnson. New York, 1894.
Illustrious Americans, Their Lives and Great Achievements. Introduction by Edward Everett Hale. Philadelphia and Chicago, 1896.
Pictorial History of the Civil War. Chicago and New York, 1899. This volume reproduces many of the rare woodcuts made from Waud's sketches which appeared in the *New York Illustrated News* in 1861.
American Graphic Art by Frank Weitenkampf. New York, 1924.
The Pageant of America (15 Vols.) by Ralph Henry Gabriel. New Haven, 1925–1929.
The Civil War and Reconstruction by Prof. J. C. Randall. Boston, 1937.
Adventures in America, 1857–1900 by John A. Kouwenhoven. New York, 1938.
An Album of American Battle Art, 1755–1918. Library of Congress. Washington, 1947.
Artists and Illustrators of the Old West, 1850–1900 by Robert Taft. New York, 1953.
Divided We Fought, a Pictorial History of the War 1861–1865 by David Donald; picture editors: Hirst D. Milhollen and Milton Kaplan. New York, 1952–1956.
Tales of the Mississippi by Leonard V. Huber. New York, 1955.
Mathew Brady, Historian With a Camera by James D. Horan. New York, 1955.
Early American Book Illustrators and Wood Engravers, 1670–1870 by Sinclair Hamilton. Princeton (Vol. I), 1958; (Vol. II, Supplement) 1968.
They Were There: The Civil War in Action as Seen by Its Combat Artists by Philip Van Doren Stern. New York, 1959.
They Who Fought Here by Bell Irvin Wiley and Hirst D. Milhollen. New York, 1959.
The Image of War by W. Fletcher Thompson, Jr. New York, 1959.
Horsemen Blue and Gray by James R. Johnson and Alfred H. Bill; picture editor, Hirst D. Milhollen. New York, 1960.
The Civil War: The Artist's Record by Hermann Warner Williams, Jr. Boston, 1961.
The Civil War, a Centennial Exhibition of Eyewitness Drawings. National Gallery of Art; Smithsonian Institution. Washington, 1961.

The Custer Album by Lawrence A. Frost. Seattle, 1964.
Embattled Confederates by Bell Irvin Wiley; picture editor, Hirst D. Milhollen. New York, 1964.
Album of the Lincoln Murder by Robert H. Fowler; picture editor, Frederic Ray. Harrisburg, 1965. (Including work by William Waud.)
The Phil Sheridan Album by Lawrence A. Frost. Seattle, 1968.
The Great Fire, Chicago 1871 by Herman Kogan and Robert Cromie. New York, 1971.
The American Heritage/Century Collection of Civil War Art, New York, 1974.

Newspapers and Periodicals

The Carpet-Bag. Boston, 1851–1852.
The Illustrated News. New York, 1853.
The Historical Picture Gallery. Boston, 1856.
The Weekly Novelette. Boston, 1857–1862. (Including work by William Waud.)
New York Illustrated News. New York, 1860–1862.
Harper's Weekly. New York, 1862–1876.
Frank Leslie's Illustrated Newspaper. New York, 1860–1864. (Works of William Waud.)
Harper's New Monthly Magazine. New York, 1866–1890.
Every Saturday. New York, 1871.
The Century Magazine. New York, 1883–1886.
Munsey's Weekly. New York, 1884.
Time magazine. New York, February 17, 1961.
American Heritage. New York, August, December, 1963.
Civil War Times Illustrated. Gettysburg, 1959–1973.
American History Illustrated. Gettysburg, 1966–1973.

Collections of Original Drawings By Alfred R. Waud

The Waud Collection, Library of Congress, Washington, D.C. (1150 sketches by Alfred and William Waud)
Estate of Malcolm F. J. Burns. (400 sketches)
The Chicago Historical Society, Chicago, Ill. (31 sketches)
The Missouri Historical Society, St. Louis, Mo. (60 sketches)
The Historic New Orleans Collection, New Orleans, La. (470 sketches)
The M. & M. Karolik Collection, Museum of Fine Arts, Boston, Mass. (12 sketches)
The Franklin D. Roosevelt Library, Hyde Park, N.Y. (2 gouache drawings)
Rev. John Morman, Lititz, Pa. (35 sketches in and around Bethlehem, Pa.)

Early in 1973 most of the original art work for Century's *Battles and Leaders of the Civil War* was discovered stored in New Orleans, and included twenty-six drawings by Alfred R. Waud. This collection has recently been acquired by the American Heritage Publishing Co., Inc.

INDEX

Figures in bold face refer to pictured subjects and Plate descriptions.

Abbott, Henry L., 162
Adams, F. Colburn, **48**
Alden, Henry M., 57
Aldie, Va., 42
Alexandria, Va., 15, 127
Allum, Arthur, 10
Annandale, Va., **25**
Annapolis, Md., 14
Antietam, Battle of, 36, 38, 107, **110–113**, 115
Appomattox, Va., 12, 51, **179**
Appomattox River, **153–154**, 177
Army of Northern Virginia, 36
Army of the Potomac, 18–19, 21, 25–26, 29, 38, 42–43, 47, 50, 93, **124, 129, 131**
Ash, Joseph P., 45
Ashby, George E., **155**
Astor, John Jacob, III, **88**
Atlanta, Ga., 27, 69
Atlantic City, N.J., 58
Aquia Creek, 41

Bailey's Cross Roads, Va., **86**
Baird, Absalom, **174**
Baltimore, Md., 38
Barlow, Francis C., 47, **151**
Barnard, George N., 31
Barnard, John G., **94**
Barnum and Beach's *Illustrated Weekly*, 12
Baton Rouge, La., 56
Battles and Leaders of the Civil War, 42, 47–48, 51, 64, 67, 83, 98, 100, 106, 116, 134, 168–169, 177, 179, 181
Bay Street, **174**
Beauregard, Pierre G. T., 50, 55
Benson's Horse Artillery, 96
Berlin, Md., **115**
Bermuda Hundred, Va., **153**
Beyond the Mississippi, 57
Blackburn's Ford, Va., **92**
Blenker, Louis, 25, 87
Blue Ridge Mountains, 43, **138**, 144
Booth, John Wilkes, 51, 183
Boston, Mass., 12–13, 15, 28, **75**
Bowen, Nicolas, **39**, 40
Brady, Mathew B., 18, 20, 31
Briscoe's Brigade, **176**
Brooklyn, N.Y., 56
Brooklyn Regiment, 14th, **111**
Brooklyn, U.S.S., 13
Brougham, John, 12
Brougham's Lyceum, 12
Brown, Joseph E., 68–69
Brown, Joseph M., 68
Brown, Julius, 69
Bryant, William Cullen, 61
Buckingham, Lynde Walter, 42
Buford, John, **129**
Bull Run, 92
Bull Run, First Battle of, 12, 15, **18–19, 20–21,** 29, 33, **81**
Bull Run, Second Battle of, 36, **106**, 117
Burns, Malcolm F. J., 7, 12, 59
Burns, Milton J., 32, 68
Burns, Mrs. Milton J. (Mary Waud), 12, 32, 69
Burnside, Ambrose E., 18, 38, 40, 42, 81, 119, 124, 186

Bush, C. G., 58
Butler, Benjamin F., 14, 19, 154, 173

Cairo, Ill., 53, 54
Cameron, Simon, 88
Cameron, Miss, **88**
Camp Lincoln, 34
Cape Hatteras, N.C., 19
Carr, Joseph B., **128, 143**
Cedar Creek, Battle of, 172
Cemetery Hill, 42, **135, 136, 137**
Cemetery Ridge, 43, **138**
Centennial Exposition, 52
Centreville, Va., 18, 108
Century Company, The, 64–65, 181
Century Magazine, 64
Chancellorsville, Battle of, 42, **131–132**
Chapin, John R., 57, 58, 93
Chapman, Frank, G., **48**
Charles River, 13
Charleston, S.C., 16, 56
Charlestown Navy Yard, 13
Charlottesville, Va., 45
Chase, Salmon P., **88**
Chicago fire, 60
Chickahominy River, 35, **94, 100**
Chickamauga, Battle of, 68
Cincinnati, Ohio, 53–54
City Point, Va., 50, 153
Civil War Times Illustrated, 7
Cold Harbor, Battle of, 50, **151**
Colfax, Schuyler, 58
Connecticut Heavy Artillery, 1st, **156–157**
Contrabands, **126**
Corcoran, Michael, 18
Couch, Darius N., 102
Couch's Corps, **132**
Crampton's Gap, Battle of, 36, 71
Crater, Battle of the, 50, **165**
Cullum, George W., **78**, **88**
Culpeper, Va., 29, **41**, 144
Cumberland, U.S.S., **82**
Custer, George A., **39–40**, 43–44, 46, 50, **94**, 145, **168–169, 172, 179**

Davidson, John W., 95
Davies, Henry E., 65, 67
Davis, Jefferson, 16, 56
Davis, Phineas A., 84
Davis, Theodore R., 27, 29, 31, 35, 52–53, 57–58, 60
Dawes, Rufus B., 111
De Hart, **128**
Demorest, W. Jennings, 13
Devil's Den, **2**, 42–43
Douglas, Henry Kyd, 107
Duane, James C., 165
Dunker Church, 38

Early, Jubal, 136, 170
Eighteenth Corps, **156, 158**
Eleventh Corps, 36, 42, **132**
Ellsworth, Elmer E., 14
Emancipation Proclamation, 126
Every Saturday, 58, 60–62
Ewell, James, 51, 136

Ewell's Corps, **178**
Excelsior Regiment, 2nd, 36, **77**
Excelsior Regiment, 5th, **101**
Eytinge, Sol, 35, 58

Fairfax Court House, Va., 33, 80
Fair Oaks, Battle of, 36, 97
Falmouth, Va., **40–41, 46**, 124
Farragut, David G., 16, 29
Five Forks, Battle of, 48–50, 186, **175**
Forbes, Edwin, 27, 42, 52, 57
Ford's Theater, 51, **183**
Fort Blenker, 25
Fort Clark, 19, **82**
Fort Fisher, 50, 173
Fort Gregg, **176**
Fort Hatteras, 19, **82**
Fort Sumter, 16
Fort Whitworth, 176
Fortress Monroe, **19–21**, 50, 84
Frank Leslie's Illustrated Newspaper, 14, 16–17, 29, 34, 42, 52, 61
Franklin's Corps, **99, 100**
Franklin Square, **59**
Franklin, William B., 36, **88**
Fredericksburg, Va., 38, **40–41**, 115–116, **118–119, 122**, 128
Fredericksburg, Battle of, **119–121**, 123
Freedman's Bureau, 49
French, William H., 120, 143
Furness, F., 46

Gaines's Mill, Battle of, **98**
Gallego Flour Mill, 51
Gardner, Alexander, 2, 31, 37, 43, 48–50, 115
Gardner, James, 30, 50
Garibaldi Guard, 26
Geary, John W., **174**
Georgia, 67
Georgia Regiment, 50th, 108
Gettysburg, Pa., **2**, 46
Gettysburg, Battle of, 32, 42, **133–138**, 186
Gibson, James, 39
Glenn, Joe, 18
Gordonsville, Va., 45
Governor's Island, N.Y., 38, 186–187
Graham, Charles K., 101
Grant, Ulysses S., 29, 47, 50–51, 58, **61, 146**, 186, 177, **181**
Griffin, Charles, 120

Hall, George B., 36
Halleck, Henry, 50
Hamilton, Schuyler, 78
Hampton, S., **93**
Hampton Roads, Va., 20
Hampton, Wade, 166
Hancock, Winfield Scott, 38, 39, 120
Hanover Court House, Battle of, **96**
Hanscom, Simon P., **48**
Harlem Heights, Battle of, 68
Harper & Brothers, 27, 32, **59**
Harper, Fletcher, 27
Harpers Ferry, 50
Harper's New Monthly Magazine, 57, 59, 63, 65
Harper's Weekly, 11, 14, 25–27, 29, 31–36, 38, 41–

190

Harper's Weekly, (cont.)
43, 47–48, 50–58, 60–61, 63, 69, 88, 90, 93, 96–97, 99, 108, 110, 113, 116–117, 120–121, 126, 128, 132, 137–138, 141, 147–148, 153–154, 160, 162, 165, 170, 172, 183
Harrison's Landing, **104**
Haskell, Frank, 133
Hatcher's Run, Va., 171
Hatteras Inlet, **82–83**
Hay, John, **88**
Hays, Harry T., 136
Hawkins' Zouaves, **82**
Hazlett's Battery, 42
Heintzelman, Samuel P., **88**
Historic New Orleans Collection, 59
Hoke, Robert F., 136
Holmes, Oliver Wendell, 31
Homer, Winslow, 34, 52
Hooker, Joseph, 42, 86, **128, 131**
House, Edward, 18
Howard, Oliver O., 49
Howells, William Dean, 59
Hudson River, **60**
Humphrey, Andrew A., **120**
Humphrey's Division, 42, **120–121**
Hunt, Henry J., 133, 135
Hunter, W. S., Jr., 13
Hunter's Panoramic Guide, 13

Illustrated London News, 11, 85

Jackson, Richard H., 156
Jackson, Thomas J. (Stonewall), 90, 102, 107
James Peninsula, 33, **93**
James River, 34–35, 50, **69,** 104, **153,** 166, 170, **182**
Jersey City, N.J., 16
Jewett, John F. & Co., 13
Jewett, Mary Gertrude, 12
Jewett, W. S., 58
Jones, W. G., **39**

Kaplan, Milton, 70
Keeler, Ralph, 58–59, **62**
Kelly's Ford, Battle of, 43, 44, 143
Kellysville, Va., 143
Kenesaw Mountain, Battle of, 67
Keppler, Joseph, 62
Kernstown, Battle of, **90**
King, John, 13
Knox, J., **48**

Lammond, Nellie, **128**
Lamon, Ward H., **88**
Lee, Fitzhugh, 108
Lee, Robert E., 36, 43, 50–51, 107, 119, 144, 160, 176–177, **181,** 186
Leggett, T. B., 13
Leslie, Frank, 27
Libby Prison, 12, 51, **182**
Little Rock, Ark., 53, **183**
Lincoln, Abraham, 16, 19, 51, **79, 88,** 129–130–**131,** 166, 183, 186
Lincoln, Mrs. Abraham, **88,** 129
Little Round Top, 42–43, 48, **134**
Logan, John A., **174**
Longstreet, James, 68, 106, 138
Loudon, Va., 115
Louisiana, 53, 58
Louisiana Tigers, 42, **135–136–137**
Louisville, Ky., 53–54
Lovie, Henri, 27
Lumley, Arthur, 18, 27, 52

Madison Court House, Va., 43
Magruder, John B., 102
Maine Battery, 5th, **135**
Maine Cavalry, 1st, **140**
Maine Regiment, 1st, **34**
Malvern Hill, Battle of, 35, **100, 102**
Manassas, Va., 18, 33, **81, 92, 106**
Marietta, Ga., 68–69, **70**
Marshall, Charles, **181**
Marye's Heights, 42, **119**
Maryland, 36
Maryland, 14
Maryland Battery, 1st, 38
Maryland Heights, **169**
Massachusetts Battery, 5th, 31; 10th, 143
Matthews Hill, **81**
McCall, George A., **88**
McClellan, George B., 19, 21, 26, 34, 36, 38–39, 41, 65, **92–94,** 99–100, 102, 104, 115, 117, 186
McClellan, Samuel A., **44**
M'Callum, Andrew, 51
McCormick, Richard C., 18
McDowell, Irvin, 18, **88, 92**
McKean, James B., 95
McLean House, 51, **181**
Meade, George G., 29, 42–43, 49, 133, 144, 186
Meagher, Thomas F., 102
Mechanicsville, Va., 95
Memphis, Tenn., 53–55
Mercier, Henri, **88**
Merritt, Wesley, 168
Michigan Cavalry, 6th, 43
Milhollen, Hirst D., 70
Mine Run, Va., 43
Minnesota, U.S.S., **82**
Mississippi River, 29, 59, 61–62
Mississippi, U.S.S., 16–17
Mobile, Ala., 56
Montgomery, Ala., 16
Montgomery, Walter, 28
Morgan, J. Pierpont, 32
Morris, Louis O., 151
Mosby's guerrillas, 42
Mountain Campaign in Georgia, 67–69
Mount Jackson, Va., **168–169**
Mud March, 42, **124**
Mumma House, **110**
Munsey's Weekly, 64

Nashville, Tenn., 53–54
Nassau Street, 15
Nast, Thomas, 19, 26, 35, 50, 57–58
Natchez, Miss., 55
Natchez, 64
National Academy of Design, The, 64
New England, 12
New Hope Church, Battle of, 67
New Jersey Sea-Board, 63
New Jersey Volunteers, 7th, **128**
Newport News, Va., 20
New Orleans, La., 16, 29, 55, 58, 62–64
New Iberia, La., 55
New York, N.Y., 12–13, 18, 27, 34, 55, 59–60, 63–64, **66,** 77, 186
New York Artillery, 3rd, **155;** 7th, **151**
New York City Directory, 12, 15
New York Fire Zouaves, 14
New York Harbor, **16**
New York Illustrated News, 13–16, 20–21, 25–28, 35, 52, 78, 84, 86
New York Regiment, 9th, **82;** 12th, **110;** 16th, **100;** 69th, 18; 71st, 18; 72nd, **104;** 77th, 95
New York World, 112

Nicolay, John G., **88,** 186
Norfolk, Va., 20, **84**
Norfolk Navy Yard, **37**

Official Records, 95
Ohio, 22
O'Sullivan, Timothy H., 31, 37

Painesville, Va., 65, **67**
Parker, Ely S., **146**
Parsons, Charles, 58
Patrick, Marsina, 49, 141
Paul, Edward A., 35
Paxton, Joseph, 15
Peacock, William, 31
Peck, John J., **88**
Peninsular Campaign, 16, 36
Pennsylvania Cavalry, 6th, 44, **46**
Pennsylvania Regiment, 48th, **161**
Pensacola, U.S.S., **76**
Perkins, Granville, 58
Perryville, Md., 14
Petersburg, Va., 16, 29, 50, **152–153–154–155–156, 158,** 165, 176, **177**
Petersburg mine, **161–162**
Pickett's Charge, 42, 43, **138**
Pickett's Division, **175**
Picturesque America, 61–64
Pleasants, Henry, 161
Pleasonton, Alfred, 114
Pleasonton's Cavalry, **114**
Point of Rocks, Va., **154**
Pope, John, 106, 117
Porter, David D., 50, 173
Porter, Fitz John, **96,** 98, 102
Porter, Horace, 177, 181
Porter, Peter A., **151**
Porter's Fleet, **173**
Port Hudson, 83
Potomac River, **15, 85,** 107
Puck, 62

Raccoon Ford, Va., 29, 49
Ramseur, Stephen D., 172–173
Randall, J. C., 70
Rapidan River, 29, 43–44, 46–47, 145–146
Rappahannock Bridge, Battle of, 43
Rappahannock River, 33, 42, **118,** 186
Rappahannock Station, Va., 31, 143
Ream's Station, Va., 49
Resaca, Battle of, 67
Reynolds, John F., 42, **133**
Rhode Island Regiment, 1st, 18; 2nd, 18
Rice, Edmund, 138
Richardson, Albert D., 40, 57
Richmond, Va., 33–34, 36, 51, 55, 58, **182**
Rickett, Robert B., 135
Ringgold, Ga., 68
Rivanna River, 45
Robinson, O'Neil W., **44**
Rush's Lancers, **46**
Ruth, 53

Sala, George Augustus, 11, 30, 49
Santiago de Cuba, 58
Savannah, Ga., 16, **174**
Sayler's Creek, Va., 51
Schell, Fred B., 27
Schell, Frank H., Jr., 57
Schenck, Robert C., 80
Scott, Winfield, 15, **78, 79**
Sears, Henry, 58
Sedgwick, John, 47, 143

Sedgwick's Corps, 31
Seven Days' Battle, 34, 36, 100
Share, H. Pruett, 68
Sharpsburg, Md., 38
Sheldon House, 47
Shenandoah Valley, Va., 50, **166, 168**–**169**–**170**
Sheridan, Philip H., 48, 50, 166, **170,** 175
Sherman's Battery, **19**
Sherman, William T., 16, 18, 27, 29, 116, **174**
Shields, James, 90
Siege of Washington, D.C. . . . , 48
Shiloh, Battle of, 27
Sickles, Daniel, 36, **85, 101,** 128
Sickles' Brigade, 35
Signal Corps, **170**
Signal Telegraph, **122**–**123**
Sims, R. M., 179
Skedaddlers Hall, **104**
Sleeper, Jacob Henry, **44**–**45,** 143
Slocum, Henry W., **174**
Smith, John E. (?), **174**
Somerset House, 12
South Mountain, Battle of, 36, 71, 117
South Orange, N.J., 65, 68–69
Spencer, Thomas, 70
Spotsylvania, Battle of, 47, 149
Sprague, Kate Chase, **88**
St. Lawrence River, 13
Stanardsville, Va., 45, **145**
Stanton, Edwin M., 186
Starr, James, 46, **131**
Stevens, G. T., 32, **135**
Stevens, Henry L., 58, 121

Stowe, Harriet Beecher, 13
Sturgis, Samuel D., 120
Sumner's Grand Division, 118
Susquehanna, U.S.S., **82**
Sylvan Shore, **154**

Townsend, George Alfred, 36, 71
Texas, 53
Thompson, D. G., **64**
Trent's House, **99, 100**
Tyler, Daniel, **19**

Union Boat Club, 13

Van Rensselaer, Henry, 78
Vicksburg, Miss., 54–55, 57
Vienna, Va., 22, **80**
Virginia Cavalry, 1st, **108**
Vizetelly, Frank, 11, **85**
Vosburgh, Abraham S., **77**

Wabash, U.S.S., **82**
Wadsworth, James S., 147
Wadsworth's Division, 47, **147**
Wainwright, Charles S., **162**
Ward, Hobart, **128,** 143
Warren, A. W., 51
Warren, G. K., **47,** 48–49, **134, 150,** 175, 186–187
Warrenton, Va., 38, 115
Washington, D.C., 12, 14, 18, 25, 33, 40, **48**–**49,** 50, 58, **172, 183,** 186
Washington Monument, 15
Washington Navy Yard, 13, **76,** 77
Washington Street, 13, **75**

Waud, Alfred R., pictured, **2, 10, 19**–**20,** 25, **30, 34, 37, 41**(?), **44**–**45**–**46, 48**–**49, 56, 62, 66, 104;** early life & work (1828–1860), 12–13; special artist for *N.Y. Illus. News* (1861), 14–15, 18–26; with *Harper's Weekly* (1862–1865), 27, 29, 31–36, 38–52; post-war career (1865–1891), 53–65, 67–70
Waud, Alfred R., Jr., 12, 68
Waud, Edith, 12
Waud, Mary (Mrs. Milton J. Burns), 12, 32, 69
Waud, Selina, 12
Waud, William, 7, 15–16, **17**–**18,** 29, 34–35, 49–51, 57–58, 70–71, 152, 154, 170–171, 174
Weir, Robert, 51
Weitzel, Godfrey, 153
West Point, 172
White House, 15, **79,** 88
White's Ford, **107**
Whitman, A., Jr., 13
Wiedrich, Michael, 135
Wilderness, 47, 146–**147**–148
Willard's Hotel, 14, **15**
Willcox, Orlando B., **146**
Williams, Alpheus S., **174**
Williamsport, Md., 43
Wilson, James H., 160
Wilson, John T., 108
Winchester, Battle of, 50, 90
Wolftown, Va., 44
Woodbury, David B., 41, 127
Woods, Charles R., **174**
Wright, Horatio B., 31

Yorktown, Va., 33–34, 93